LANDSCAPES AUGUST SANDER

LANDSCAPES

PHOTOGRAPHS 1926–1946

AUGUST SANDER

WITH AN ESSAY BY WOLFGANG KEMP

TRANSLATED BY ROSE RITTENHOUSE

THE UNIVERSITY OF CHICAGO PRESS

CHICAGO AND LONDON

Illustration Credits
Figure 1: Illustration by Irmgard Hantsche, from Gertrude Cepl-Kaufmann and Antje Johanning, *Mythos Rhein: Kulturgeschichte eines Stromes* (Darmstadt: Wissenschaftliche Buchgesellschaft, 2003); Figures 2 and 19 and Plate 3: Photography collection at the SK Stiftung Kultur, Cologne; Figures 9–14: Private collection, Munich; Figure 15: LVR-LandesMuseum Bonn; all other plates and figures: Schirmer/Mosel archive, Munich.

The University of Chicago Press, Chicago 60637
The University of Chicago Press, Ltd., London
English translation © 2016 by The University of Chicago
Published 2016.
Printed and bound in Italy by Printer Trento

25 24 23 22 21 20 19 18 17 16 1 2 3 4 5

ISBN-13: 978-0-226-39946-1 (cloth)

Library of Congress Cataloging-in-Publication Data

Names: Sander, August, photographer. | Kemp, Wolfgang, 1946– writer of added commentary.
Title: Landscapes : photographs, 1926–1946 / August Sander ; with an essay by Wolfgang Kemp ; translated by Rose Rittenhouse.
Other titles: Rheinlandschaften
Description: Chicago : The University of Chicago Press, 2016. | "Contains added text by Wolfgang Kemp translated into English."
Identifiers: LCCN 2016014274 | ISBN 9780226399461 (cloth : alk. paper)
Subjects: LCSH: Landscapes—Rhine River Valley—Pictorial works. | Rhine River Valley—Pictorial works. | Landscape photography.
Classification: LCC DD801.R74 S315 2016 | DDC 914.3/400222—dc23 LC record available at https://lccn.loc.gov/2016014274

♾ This paper meets the requirements of ANSI/NISO Z39.48-1992 (Permanence of Paper)

Contents

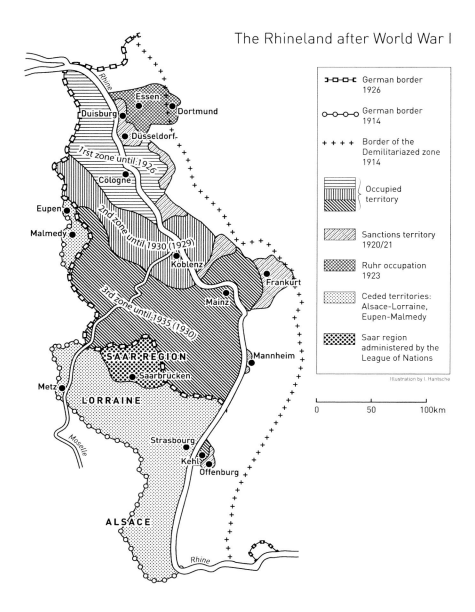

The Rhineland after World War I

German border 1926

German border 1914

Border of the Demilitariazed zone 1914

Occupied territory

Sanctions territory 1920/21

Ruhr occupation 1923

Ceded territories: Alsace-Lorraine, Eupen-Malmedy

Saar region administered by the League of Nations

Illustration by I. Hantsche

0 50 100km

Rhine

Essen

Duisburg

Dortmund

Düsseldorf

1rst zone until 1926

Cologne

Eupen

2nd zone until 1930 (1929)

Malmedy

Koblenz

Frankurt

3rd zone until 1935 (1930)

Mainz

SAAR REGION

Mannheim

Saarbrücken

Metz

LORRAINE

Moselle

Strasbourg

Kehl

Offenburg

ALSACE

Rhine

1. The occupied Rhineland after World War I

The Lament on the Rhine

In 1935, August Sander published the last of his six books of landscape photography; this one was devoted to the Lower Rhine. Forty years later, Schirmer/Mosel, established in 1974, introduced as its first publication *August Sander Rheinland-schaften* (*Landscapes*), which has now been reissued in honor of the publishing house's fortieth anniversary. In 1974, Lothar Schirmer asked authors for more than the usual type of fore-word that had introduced photography art books since the 1920s. He wanted a balance—at least in a material sense—between text and image. He got it. In a somewhat circuitous way, I tried to bring together the two disparate territories of art history and the history of photography, switching back and forth between them almost like a translator.

Among art historians, only one in the Federal Republic of Germany was interested in photography: the late Josef Schmoll gen. Eisenwerth. He came to photography in the same way as me: as an instructor and then professor at the State School of Arts and Crafts in Saarbrücken, he met Otto Steinert and remained loyal to him and the history of photography, although with a very different orientation as a specialist in medieval and modern sculpture.

When I arrived at the former art academy in Kassel to join the art faculty of the university, Lothar Schirmer's assignment to write a piece on Sander as well as my encounters with Floris M. Neusüss, Gunter Rambow, and many students persuaded—or, rather, required—me to gain some expertise in photography and its history.

So I completed my difficult interpretive work for the essay, the book appeared, and it even won recognition for its design. Then, within a year my text was, perhaps not obsolete, but certainly following a different path than others. In a long review in the journal *Kritische Berichte* and a Bonn exhibition with the title *Gemalte Fotografie—Rheinlandschaften* (*Painted Photography—Rhine Landscapes*), Herbert Molderings and Joachim

Heusinger von Waldegg revealed a dimension of the material that I had not thought important while looking at the history of the landscape genre: the photographic and artistic appropriation of the Rhineland in the period after World War I.[1] The historiography of photography has since continued along this latter path. While I attempted to explain what Sander owed and contributed to the history of landscape painting, those other critics effectively grounded Sander's work and freshened up his black-and-white views with local color. Their perspective was particularly noteworthy in one regard: I had assumed that a great photographer could do anything, including landscapes. But they were right to expect that a man who had focused on portraits needed a special impulse, and likely also had some learning to do, when he switched to the landscape genre.

My original essay from forty years ago does not need to be reprinted here. Since that time, the history of photography has become its own discipline, one that participates in the most advanced theoretical developments and, indeed, even drives them. What's left to do? There's no turning back after Molderings's and Heusinger von Waldegg's contemporaneous approach to the Rhine landscapes. But we can give it a new twist. The curious thing is that during the highly politicized 1970s, these authors missed a crucial aspect, which is strikingly demonstrated in figure 1—namely, the exceptional political situation in which the Rhineland found itself. This map was also a Rhine Landscape.

A work that became famous was Sander's portrait of Anton Räderscheidt, achieved by virtually ambushing the artist on an early Sunday morning in 1926. Here is Räderscheidt on Cologne's empty Bismarckstraße in excessively proper street clothes, the strictness of which agree with the surrounding Wilhelminian architecture even as they stand in complete contradiction to it. Here, Sander held to a compositional formula that had been Räderscheidt's hallmark since 1920: the artistic individual as a constructivist generalization, but formally and stiffly dressed, in an urban wasteland. A second version of

this photograph has also survived (fig. 2), this one taken at a spot several hundred meters away. The street is still eerily empty, but now the painter stands between two piles of smashed horse droppings.[2] It goes without saying which image was successful or, rather, authorized—the horse manure, an organic and ultimately narrative prop, did not agree with the overall character of constructivism. The Cologne "progressives," who counted Räderscheidt among them, had learned quite a bit from the Italian Metaphysical Painting movement: for them, "metaphysical" meant emptiness and solitude. What Siegfried Kracauer said, speaking protoexistentially in 1922 about the "bearer of spirit," fits this photograph: "Flung into the clear infinity of empty space and empty time, in the face of material divested of all meaning, the subject must grapple with and form this material according to the ideas within himself (and rescued from the era of signification)."[3] (It

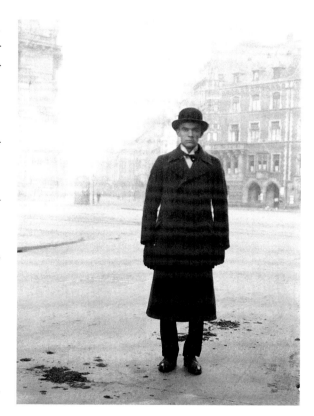

2. August Sander, *Anton Räderscheidt*, 1926

must be said to have been the product of a century far removed intellectually, if not chronologically. For the Cologne "progressives," an emptiness robbed of meaningful coherence might have made sense as a signature of the endlessly evoked human "social atom," as evidence of the alienation of the modern individual, who even dresses up "senselessly" as a citizen instead of standing proudly alone. For Sander's portrait work, this inversion was no useful recipe—he sought more of a "reality rethought through meaning." Most of Sander's other subjects appear not to share the experience of fragmentation— they possess an astonishing "sovereign power"—astonishing when one considers the time period, in which experiences and voices like those of Kracauer dominated, whose explanations we could once more associate with Sander's portrait of Räderscheidt: "In the most recent past, people have been forced to experience their own insignificance—as well as that

should be noted that Kracauer repeated a similar version of this statement during the same year in an issue of the journal *Die Rheinlande*.[4]) For Kracauer, however, what is important is not the ejection into emptiness but rather the ability "to successfully move from the empty space of pure thought into the full space of a reality rethought through a highly transcendental meaning."[5] But here Kracauer is asking too much of Sander's portrait of Räderscheidt. This portrait relies on his attitude, and especially on his outfit, complete with stiff hat, which makes him unassailable. At the same time, Beckmann chooses this stance, which must, above all, avoid expressing any kind of bohemianism. Contextually speaking, the Wilhelminian city

of others—all too persistently for them to still believe in the sovereign power of any one individual. . . . Today the creative artist has once and for all lost faith in the objective meaning of any one individual system of reference."[6] Strangely, these words from Kracauer, especially his last sentence, mesh well with a cryptic painting that was made by Räderscheidt himself and that has since been lost; it lives on only in a print by August Sander (fig. 3). The original belonged to the great Rhenish collector and patron Paul Multhaupt, whose collection of modern art, exhibited in early 1933, disappeared in the chaotic first year of National Socialist rule. Multhaupt himself had taken his own life shortly prior to that. This panoramic work, approxi-

mately 2.2 meters wide and titled *Der Rhein* (*The Rhine*), was likely created circa 1925. If Räderscheidt has been robbed of any "individual system of reference" in Sander's portrait of him, and if we are unable to find in this "one person" any trace of a "sovereign power" (look again at Räderscheidt's dark hands, hidden in gloves and hanging like prostheses), then the isolation, as well as the inner and outer fragmentation seen in this painting, made by those very same hands, have increased to a grotesquely forbidding extreme. The figure in the painting, his back turned to us, faces the river. But frozen in this position, he is a far cry from the romantic alternative of, say, Caspar David Friedrich. While for Friedrich, the internal and the external animate each other, for Räderscheidt, the "system of reference" has been disrupted. We are unable to read the thoughts on the turned figure's face, but the fact that the man is armless and naked is enough for us to interpret him as representing ejection, isolation, alienation. That he stands on a small slab, similar to a pedestal, makes him a companion to the many unrepresentative monuments that Giorgio de Chirico placed in the deserted spaces of his works. In view of the Italian artist's criticism of monuments and rejection of *passatismo*, the cult of the past, we could attribute the same purpose to Räderscheidt's painting, this time his antipathy to a Rhine romanticism. "Räderscheidt casts the oft-evoked joining of landscape, history, river, and human in a negative light. His figure, a naked torso of a young man on a pedestal, bald and stocky, offers him the opportunity for an early 'mockery of the German intellectual philistines' eternal desire for ancient Greece.'"[7]

We have without doubt arrived at a posi-

tion antithetical to Rhine romanticism. But would this negation yield adequate visual content? What does Räderscheidt—the artist who, first as a Dadaist and later as a New Objectivity painter, clearly fought against the nineteenth century—have to say about the Rhine of the 1920s? The Rhine is an empty white band, both riverbanks dark and equally vacant, the man faceless and nude. Surely he is not Father Rhine, nor can he be a stalwart representation of the watch on the Rhine. But could the figure perhaps be a version of the watch on the Rhine stripped of its armor and robbed of its powerful arms?

Alongside Räderscheidt's painting, I offer as a different kind of modern Rhenish symbol the logo of the exhibition *1000 Jahre Kunst und Kultur am Rhein* (*One Thousand Years of Art and Culture on the Rhine*), a design that was distributed widely on posters, letterheads, and catalogs in 1925 (fig. 4). What a shame that we do not know exactly when Räderscheidt's *Rhein* was created. A dating after May 1925 could mean that Räderscheidt's painting is to be understood as an answer to this new logo, as the statement of a man who had prominently represented Rhenish issues since 1918. But what does this logo say, and out of which circumstances did it develop?

The millennial anniversary referred to a rather farfetched historical account that posited the 925 annexation of the Middle Frankish kingdom of Lotharingia into the East Frankish kingdom under Henry I; this union combined the regions to the left and right of the Rhine into one territory falling under German rule. All of the region's major cities celebrated the anniversary with ceremonies; parades; musical and athletic events; and exhibitions, the highlight of which was

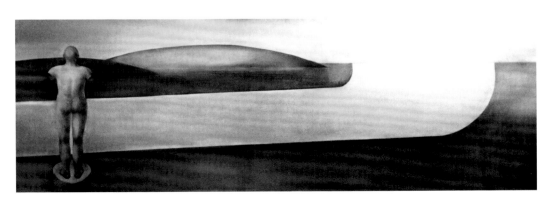

3. Anton Räderscheidt, *The Rhine*, painting, 1925 (now lost), photograph by August Sander

Cologne's *Jahrtausendausstellung der Rhein-lande* (*Millennial Exhibition of the Rhineland*), an array of around ten thousand objects. But even the smaller locales expended great effort to celebrate this totally unfamiliar jubilee: "The city of Düren's millennial celebration, for example, which took place from July 5–12, 1925, consisted of a 'floral procession' of automobile clubs, sporting events, concerts, a youth festival with music and dancing, illumination of the city, a parade, as well as an exhibition on regional history."[8]

The real nature of the celebrations was political, to an extent regio-political. After 1919, the Rhineland was an occupied zone. The Americans, British, French, and Belgians occupied different swaths of land on either side of the Rhine for varying amounts of time and with varying degrees of dominance. During the Ruhr crisis of 1923, the French also took control of that region. The inhabitants of the Rhineland, including August Sander and Anton Räderscheidt, carried with them an *Ausweiskarte*, a type of personal identification, which explicitly stated: "Einwohner des besetzten Gebietes. Living in occupied territory. Demeurant en zone occupée." No easy paper to bear. The thousand-year celebration, then, was meant to prove that the Rhineland had already made European history, serving as a "cultural bridge," a "street of people and ideas," and a "great mill of nations" (Carl Zuckmayer) churning together the world's peoples long before the existence of the current nation states—essentially since Roman times, but certainly since the High Middle Ages—and under German leadership, as the majority of the voices stressed.

Nowhere was the "war after the war" carried out more fiercely than in the Rhineland. France, after all, had been forced to abandon in Versailles its plans to claim the area to the left of the Rhine all for itself (and Belgium). But it refused to give up completely and supported separatist movements,

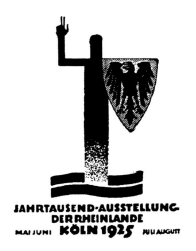

JAHRTAUSEND·AUSSTELLUNG·
DER RHEINLANDE
MAI JUNI **KÖLN 1925** JULI AUGUST

4. Logo of the exhibition *One Thousand Years of Art and Culture on the Rhine*

which would have created in a Rhenish nation a buffer zone that could have been more easily influenced. But France's efforts were to no avail: the Rhineland stood by Prussia, even if that choice was also an unhappy one. Looking at a map of this region in a historical atlas (fig. 1), we can well understand the words of Alfons Paquet, the great thinker and voice of the Rhineland movement, when he found in this "destructively divided" territory a reflection of Europe as a whole. At a conference for Rhenish writers in 1927, he stated, "For the suffering of this entire continent, which is now divided into thirty-five nations that are watching each other jealously, intolerably burdened with debts, and armed to the teeth, is reflected in the experiences of the Rhineland. And the Rhineland, striving outward from an inner sense of cohesion, reflects our entire continent, richly populated and interwoven with tradition, which needs new goals and a vision of its future to show just how youthful its true nature is."[9]

The Rhine was promoted as the "river of destiny," the "European Ganges," and even the "global river of longing." And many shared Paquet's rigorous pursuit to "fill the word 'Rhenish' with new meaning." In 1920, Paquet published in book form a November 1919 speech made in Cologne on the topic of "Der Rhein als Schicksal: das Problem der Völker" ("The Rhine as Destiny: The Problem of the People"). Three years later, he published *Der Rhein: eine Reise* (*The Rhine: A Journey*), then in 1928 the volume *Antwort des Rheines: eine Ideologie* (*The Rhine's Answer: An Ideology*), and finally, in 1941, during the war, *Die Botschaft des Rheins* (*Message of the Rhine*). It became increasingly difficult to create an effective title including "Rhine." Carl Maria Weber released a short anthology in 1919 named *Der ekstatische Fluß: Rhein-klänge ohne Romantik* (*The Ecstatic River: Rhenish Reverber-*

ations without Romanticism). Josef Winckler, coeditor of *Das Rheinbuch* (*The Rhine Book*) (1925), published his poetry as *Der Ruf des Rheins* (*The Call of the Rhine*) (1923). The volume begins with the rhapsody "Der Rheinbagger" ("The Rhine Dredger"), a poem addressed to a dredger and hundreds of mermaids, who extoll their waterway, "Enchanting river, holy road, / global pulse, ship's wake, assembly line, / you exquisitely bright tide of lore, / flow on, flow on!"[10] The most productive of the Rhineland poets (active after 1918, after 1933, and after 1945), Otto Brües, one of Sander's friends, who, incidentally, also reviewed Räderscheidt's painting, attempted an extremely matter-of-fact title with *Der Rhein in Vergangenheit und Gegenwart: Eine Schilderung des Rheinstroms und seines Gebietes von den Quellen bis zur Mündung, mit besonderer Berücksichtigung von Land und Leuten, Geschichte, Geistesleben und Kunst, Landwirtschaft und Industrie* (*The Rhine from the Past to the Present: A Description of the Rhine River and Its Surrounding Region from Its Source to Its Mouth, with Special Focus on the Land and People, History, Intellectual Life and Art, Agriculture, and Industry*)—a publication released to coincide with the thousand-year celebration. His *Rheinische Sonette* (*Rhenish Sonnets*) (1924) also sounds quite austere, but *Der heilige Strom* (*The Holy River*), which appeared in the series "Beiträge zur Rheinkunde" ("Contributions to Rhine Studies"), was finally a little smoother. To Herbert Eulenberg, considered by many the prototypical Rhenish writer, remained such dull titles as *Das Buch vom Rhein* (*The Book of the Rhine*) and *Um den Rhein* (*About the Rhine*). Perhaps it has now become clear that the poets, too, imbued the river with character and a voice, that the Rhine was for them the current of time, a geopolitical tool for tackling the most urgent concerns of the era.

From all of the poems that were written back then, the one that most closely approaches Räderscheidt's painting is the "Klage am Rhein" ("Lament on the Rhine"), published in 1921 by Josef Winckler:

No ship
proudly marks the abandoned current, the harbors shiver,
the terribly despondent day creeps by.
Where are you
singers of the Rhine, my proud brothers? . . .
No exalted caller as in the olden days
No noble boasting, eloquent proclaimer
of justice, of freedom—no one—no one.[11]

Combined here are two motifs that could be meaningful for the interpretation of Räderscheidt's painting. Along the Rhine, all is still. The poets have fallen silent, and there are also no more ships—the most important waterway in Europe has ceased operations. But both of these images are wrong. Even if the Rhine no longer produces romantic reverberations, it still provokes and inspires unbelievably rich writing, as can be seen in the above short literature overview—and we have not even begun to speak about the artworks on the theme. After trains, travel by ship on the Rhine was the most important mode of transportation in the Weimar Republic, although one thing had changed: Germany no longer reigned supreme over the river (from Lake Constance to its mouth)—the river had been internationalized in Versailles. This fact, while not diminishing the use of the river, may have contributed to the lament that everyone—not just Winckler—now began to sing, the lament over neutralization, over the foreign gunboats on the river, the occupied fortresses and castles along the Rhine, and the many goods and raw materials that were carried away on it toward France as reparations. The immense amount of activity on and along the river, as well as the epoch-making production and fostering of ideas, programs, and artworks in the name of the Rhine and the Rhineland: all of this took place—and ended in images of positively existentialist emptiness—not only with Räderscheidt and his painting of the Rhine but also with Sander and his vacant landscapes, photographs that often prompt one to question exactly when they were taken.

The fact of the region's partial expropriation apparently evoked the sense of a much larger void.

Also strange is the idea that a mere symbol, which now appears without even context, could make such a lonely impression. The logo of the millennial celebration (fig. 4), in direct contrast to Räderscheidt's helpless torso before the Rhine landscape, is the image of German resistance. A highly abstract, knightly, helmeted figure stands in the middle of a green river and raises one hand in oath while the other holds up the republic's coat of arms. It probably should not be assumed that the lower portion of the figure is becoming soaked in the river; instead, the Rhine appears to be illuminating the figure from below. This is very clearly the watch on the Rhine, and it is turned toward France, which in 1925 still took the occupation quite seriously. That the French permitted this memorable and unambiguous logo at all is a wonder, for they were at first strongly opposed to the celebration and relented only once the public events were free of any possible military or political associations and the singing of the national anthem had been removed from the program.

Räderscheidt's naked man represents a figure as similarly abstract and symbolic as the knight on the logo. But instead of standing in the river, he stands on the shore, and no matter which bank he is on, he holds no authority over it. He can neither swear an oath nor raise an emblem high. We see in him a figure of impotence in a European power struggle that was disproportionately relevant and urgent compared to any intellectual reservations against the native tradition of Rhine romanticism. But let us look more closely at this figure's position. Räderscheidt lived and worked in the portion of Cologne to the left of the Rhine. From that perspective, the naked torso would be looking at the region to the right of the Rhine, and to the right would be visible the slopes of the Seven Hills range. Granted, the Seven Hills are not directly visible from Cologne, but they represent more generally the mountain-lined Middle Rhine. The only problem with this positioning is that for the

river, which flows to the left, very little room remains in the composition to suggest the continued movement of the current. Now, this painting was not free-standing, but was intended as a mural in the Multhaupt house in Düsseldorf, and could, thus, if looked at from the right bank, help provide the sense of a flow to the right and bring the sea into view. Admittedly, no mountains stand across the river from Düsseldorf, but perhaps we should treat this as a case where the painter conceived of the river's representation just as generically as he did that of his figure: the mountains represent the Middle Rhine, and the endlessly flat plain of the Lower Rhine would move along the right side. But in that case, no further identification of the man is possible. If he were standing to the left of the Rhine, one could imagine that he embodied France's futile attempt on the region—which would mean that this painting makes a more powerful statement than even the mighty knight of the logo—but one could also conclude that he stands for the "lament on the Rhine," though here a lament without any romantic sentiments: it is really about the political and economic situation of a German land under foreign occupation.

"On January 31, 1926, the British pulled out of Cologne. At midnight, the German Bell on the Rhine heralded the new day, the free day, the German day. For the first time, the ninety million people on both sides of the borders could hear it."[12] So goes a quote from Arnolt Bronnen's novel *Kampf im Äther* (*Battle in the Ether*), a book from an author who had previously brought to the stage the separatist revolt of 1923, the proclamation for a Rhenish republic, in his drama *Rheinische Rebellen* (*Rhenish Rebels*). In the novel, the "German Bell" stands for all of the German radio stations that on this night broadcast the so-called liberation ceremony. For the first time,

those in the Rhineland could now listen to the radio. Liberation from the occupying forces took place at the same time as the liberation of the new medium. The bells began ringing on the radio and in all of the towns after Mayor Konrad Adenauer, standing before the Cologne Cathedral, ended his speech with these words: "Well then! Let us raise our hand in oath! And all of you in German lands who are with us in spirit, swear with us! Let us pledge unity, loyalty to the people, and love for the Fatherland! Call out with me, 'Germany, beloved Fatherland, three cheers to you!'"[13] The gesture by the knight holding watch on the Rhine has become here a mass movement. This nighttime scene, depicted from the perspective of the press illustrator for the Leipzig newspaper *Illustrierte Zeitung* (fig. 5), is reminiscent of a high mass, even though it is occurring outside in the city and not within the cathedral. The modern age contributed to the backdrop its electric lighting and the wires stretched out for the transmission of the audio. Of course, the Allied occupation of the Rhineland was not yet over. Finally, on June 30, 1930, the occupied forces withdrew completely, offering the occasion for many more celebrations. But the beginning of this process in Cologne occurred during a time of economic recovery and strengthened regional awareness, which found a fitting expression in the first radio broadcast uniting the Rhineland both internally and with the rest of the republic.

In fact, 1926 saw "Rhineland studies" reach a new level, as this new field developed along with an interdisciplinary method that was quite unusual for its time. We are talking about regional history—today called *Kulturraumforschung* (the study of cultural areas)—a platform through which history, geography, the sciences, and cultural studies came together. "Approaches that were originally historical, folklorish, statistical, geographical, and linguistic in nature fused in regional historical folk research to create an interdisciplinary, historically grounded science of German 'folklore.'"[14] Having conquered personal and national history, as well as geography's "boundedness" to the

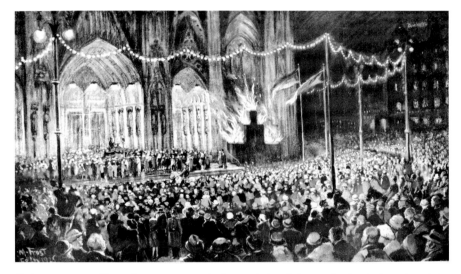

5. Anonymous, liberation ceremony in front of the Cologne Cathedral on the night of January 31, 1926, *Illustrierte Zeitung*, March 1926

earth, the new discipline highlighted people as the subject of interest, and that now meant charting "the people as a whole" and the entirety of German history. Seeing the history of Germany as "the history of its people" was necessary to Hermann Aubin, "for only then can we comprehend German history in full." Regional history, whose approach might appear to be one of diffusion or partialization, was thus in actuality striving toward "the whole" on the basis of a multidimensional point of view. Hermann Aubin, professor at the University of Bonn, initiated this research direction and founded its institutional home, the Institute for Regional History. For financial reasons alone, establishing new disciplines and institutes after the war was no small feat, but in this case, the reaction to the Allied occupation meant that Aubin found enthusiastic support from the Prussian ministry and private donors. The Bonn institute was the first and soon just one of many such institutes and projects that would develop across the Weimar Republic and Austria.

Regionalism reached its peak during the period between the wars. Looking again at the Rhineland's situation, a driving

force was arguably the partial foreign rule, as well as the lack of an overt reshaping of the Weimar Republic's territory. The 1919 constitution did not provide a list of the free states that together formed the nation. Instead, the burdened remains of the German Empire were simply adopted along with its dynastic divisions. This meant that the republic consisted of a major state like Prussia, with its thirty-eight million inhabitants, along with a tiny state like Schaumburg-Lippe, where only fifty thousand lived. Regionalism flourished across the precarious internal borders, which were to a large degree of contingent origins. Regionalism also provided a sense of mission to those who were no longer able to muster up enthusiasm for the Fatherland as a whole. And all those who could no longer travel abroad practiced regionalism out of necessity. In a 1915 article boldly titled "Reiseziele nach dem Kriege" ("Travel Destinations after the War"), the Bavarian journalist Josef Hofmiller predicted, "It will be necessary for us to become better and better acquainted with our magnificent Fatherland. We southern Germans should restrain our old urge to head south and should first travel to middle and northern Germany. The northern Germans shall serve as a model for us in this respect, for they know our land infinitely better than we know theirs. Have we not felt positively ashamed in recent years—as Langewiesche came out with his collections of German cathedrals, German sculpture, and German baroque works, and Piper published the "Schöne deutsche Stadt" ("Beautiful German City") series—about all that we have yet to know, and have we not vowed to finally stop traveling to distant locales when good ones, the best ones, can be found so close by?"[15] Hofmiller's reference to the genre of photography art books deserves first mention. This medium was expanded enormously in the 1920s; many photographers of the time met the demand with their own projects or commissioned shots. The breadth and depth of the photographic coverage of Germany was noteworthy: the monumental volume *Das Land der Deutschen* (*The Land of the Germans*) by Eugen Diesel contained 481 images.

The second and most important prediction that Hofmiller got right concerns the popularity of domestic travel, which lasted until at least 1924 and was primarily the result of German financial impoverishment and troubles obtaining the necessary currency and visas. But whatever the reasons behind it, a form of tourism established itself in Germany. This included areas beyond the traditionally popular ones in the country; as Hofmiller put it, "None of us knew Germany."[16] It goes without saying that the exploration of a deep, inner Germany had already been practiced before the youth movement, but now everything was planned in German fashion down to the last detail, and trips became a means of expression for the postwar generation. The Weimar Republic has been highlighted as a breakthrough period in the history of tourism. Concepts like the winter season and the weekend emerged, and the number of travel agencies grew rapidly, from 119 establishments in 1907 to 364 in 1925, and then on to 499 establishments with 2,910 employees in 1933.[17] Already in 1924, Döblin wrote with true Berlin chutzpah (although he certainly did not speak for all Berliners), "I have also performed this year's sacrificial ritual of the Germans. I traveled abroad. Because of the Rentenmark, not because of my own preferences. I am still of the opinion that the regions around Berlin—Wannsee, Schlachtensee—are among the most beautiful areas and spas."[18]

The whole industry required the offering of goods and services: cards, postcards, and guides for immediate use; illustrated books to aid preparation or awaken memories; and exhibitions that documented their regions in images and objects such that the shows were also depicting a travel destination—the millennial celebration was only the most prominent example. This work at the front lines of German studies saw scientific and institutional support. The Rhenish photography archive was established in 1926 (while Foto Marburg had already been around a little longer), and the Office for Regional History also began its efforts. In addition, the interwar period was the great epoch of regional monographs, in which laypeople and scien-

tists mapped their small territory in a multidisciplinary mosaic; meanwhile, art history continued its inventory work with architectural monographs, among which the landmark studies of the Cologne Cathedral (Paul Clemen), the Trier Cathedral (Nikolaus Irsch), and the Church of St. Elizabeth in Marburg (Richard Hamann) stand out. After World War I, art history in general, a discipline invented by the Germans, became the art history of Germany.

The Panorama and the Sound of the Rushing Rhine: August Sander Enters the Landscape

August Sander witnessed, participated in, was affected by, and benefited from these years on the Rhine, which were as exciting as they were difficult. He had become a regionalist by at least this point. One could call him a member of the "Rhineland movement"—in a manner of speaking, he was part of its cultural arm. While he did name his first published collection of photographs *Antlitz der Zeit* (*Face of Our Time*) and call his great project, one that had occupied him since the 1920s, *Menschen des 20. Jahrhunderts* (*People of the Twentieth Century*), almost all of Sander's subjects came from the Rhineland (in the widest geographic sense), so much so that he eventually felt compelled to cast his net a little wider while on a trip to Berlin. But this did not really change the situation, either quantitatively or qualitatively. He was certain that by maintaining a strict focus on occupation and social type, he could dispel any suspicion that he had focused too narrowly on one group of people. By doing this, he thought to do justice to the richness—a product of progressive differentiation—of the "time," the "twentieth century." But could one also say that he preferred to engage as a regionalist with the "land" over the "people"? That is no easy question to answer, for the symbiotic relationship between the land and its people never ceased to interest him, and he refused to treat landscapes or portraits independently of each other, whether for a single image or the family of images that he called a portfolio. We must return to this. When then did his interest in the land begin? Without naming a specific date, August Sander reminisces that he "hiked with my camera for the first time along the Seven Hills range in the 1920s." "On a cheerful spring morning, I packed my things and wandered through the Nachtigallental (Nightingale Valley). Halfway up, I climbed a hillslope, and at the top I discovered that I was standing on the hill named Wolkenburg. Here before my eyes was a panorama of unbelievable beauty. And breaking through the prevailing stillness to reach me was the eternal sound of the rushing Rhine."[19]

In any case, the obvious expectation that Sander would have jumped completely into his *Menschen des 20. Jahrhunderts* project after the war would be incorrect, as the business of a large studio would not have allowed that. The interwar period was without doubt a time of genre-crossing photography and paralleled in a sense the new phase of interdisciplinarity seen in cultural studies. Sander photographed artworks for reproduction purposes, new and old architecture, interiors and the urban landscape of Cologne, as well as social gatherings extending beyond just Carnival. He needed and wanted to be versatile: for the program guide for the new Cologne broadcasting company WERAG (founded 1925), Sander delivered almost one hundred text illustrations and eleven covers, including numerous landscapes and buildings.[20]

But 1925/26 may have been the time during which Sander's photographic version of regional studies found their purposeful beginning. At least two impulses are responsible for this. The first may have developed out of his need to clarify the intentions and goals behind his portfolio work. Let us return to this internally driven impulse later. The second was external: a commission. In 1926, the writer Hans Ludwig Mathar (fig. 6), who was friends with Sander, invited the photographer to prepare contributions for a volume he was planning, *Der Mit-*

telrhein (*The Middle Rhine*), and offered advice and suggestions. According to Mathar, the photographs should "attempt to capture the greatness of Rhenish culture in artistic images that absolutely demand lasting significance."[21]

Hans Ludwig Mathar: The Whole Rhineland

And now a word on Mathar, who is, next to Brües, Winckler, and Eulenberg, the most important of the Rhenish regional writers. Like his colleagues and competitors, Mathar (1882–1958), a secondary-school teacher in Cologne, did not focus solely on the local, although he understood himself to do so. He came from Monschau, called Montjoie until 1918, a town on the Belgian border at the foot of the High Fens. Crucially, this was a typical situation for a regionalist during the postwar period: Mathar came from a border region that was fighting for its existence and German identity. The areas of Eupen and Malmedy had to be ceded to Belgium, and Mathar therefore wrote "borderland" novels or equivalent novellas taking place in, for example, Monschau (*Die Monschäuer* [*The People of the Monschau Region*], 1922) or the High Fens (*Settchens Hut: Eine altfränkische, aber lustige Geschichte vom Venn* [*Settchen's Hat: An Old Fashioned but Amusing Story of the Fens*], 1925; *Das Schneiderlein vom Hohen Venn: Ein Roman zwischen zwei Völkern* [*The Little Tailor from the High Fens: A Novel between Two Peoples*], 1932); these novellas can also be definitively called borderland works, such as *Straßen des Schicksals* (*Streets of Fate*) (1933). And so Mathar tried to reoccupy the Eupen-Malmedy area anew in a literary sense. But at the same time, he felt responsible for the Rhineland as a whole and published books with titles and themes like *Ein rheinischer Tuchmacherroman* (*A Novel about a Rhenish Weaver*) (1929), *Drei Moselgeschichten aus drei Jahrhunderten* (*Three Moselle Stories from Three Centuries*) (1925), and *Wetter und Wirbel: Altkölnische Geschichten* (*Weather and*

Turbulence: Stories of Old Cologne) (1925). As a nonfiction writer, Mathar was similarly concerned with the "indivisible" Rhineland, as if despite the internal borders and vulnerable zones—look once more at figure 1—what counted was preserving its totality and unity. Mathar published eleven books, many illustrated, about places, districts, and landscapes on the Rhine and its tributaries. He expressed himself about the Rhineland's postwar situation indirectly: on the one hand, as mentioned above, he paid particular attention to the borderlands—the places "between the peoples"—and on the other hand, he turned to the history of the occupied Rhineland. Concerning the latter, of relevance is a significant piece of prose, titled "Montroyal," that appeared in the volume *Die Mosel: Bilder von Land und Kunst* (*The Moselle: Images of Its Land and Art*) (1924). Here, the man from Montjoie wrote about the history of the fortress Montroyal, which the French constructed on a mountain rising above the old town of Traben—or rather, the French had it constructed through the use of the local population's forced labor. From there, the French laid waste to cities, cloisters, and castles on the Moselle; this was during the war against the Palatinate that lasted from 1688 to 1697, the result of a spurious inheritance claim. One is reminded of the destruction of the Heidelberg castle—or perhaps one *could* be, as Montroyal remains shrouded in the unknown: "Horrible loneliness, abandoned, forgotten, like a grave of the damned." Sander's friend was no New Objectivist. Like other Rhineland writers, including Winckler and Eulenberg, he tended toward a neobaroque diction, and not only because this particular text took place in the time of Louis XIV: "Lavish banquet of the officers, particularly of the inhumane Monsieur du Saxis, *lieutenant de roi*, who dined with all of the officers *in curia magnis sumptibus solius civitatis*. Endless payments, wine, hay, and oats went to the army at Koblenz, while oats, meat, and hay, hundreds of rations went to Montroyal, as well as a zulast of wine *de anno* 1684, a splendid drink. Thousands of Reichstaler, acquired *incesse-*

ment by publican Matthias Burchart in Andernach."[22] Mathar's strained style of speech, peppered with quotes and foreign words, often switches into a personal baroque, a collage attempting to bring *Simplicissimus* back into the present. But one must always consider such excerpts in light of the postwar period, as the French resided in the Koblenz palace for the second time and, together with high-ranking representatives from the other occupying powers, held grand celebrations while the Germans watched from the outside and, responsible for the costs of the occupation, picked up the tab. At the end of the chapter "Montroyal" stands written, "Life drained away, while the curse remained."

As mentioned above, Mathar wrote eleven nonfiction books on Rhenish topics. He anticipated that his greatest project, *Die Rheinlande: Bilder von Land und Kunst* (*The Rhineland: Images of Its Land and Art*), would contain eight vol-

6. August Sander, *The Writer* (Ludwig Mathar), 1926

to create a book on Sardinia, a project that never came to fruition and whose photographs, taken in 1927, were first exhibited in 1995.[23] One of Sander's portfolios, originally part of Mathar's estate, has survived in Lothar Schirmer's collection. The portfolio includes prints meant for this volume, and additional images are part of the photographer's own estate. Thus, we know that Sander turned to landscape themes no later than 1926.[24] Then, as he began to publish small booklets of his landscape photographs in 1933, he could already fall back on a substantial stock of images. Between 1933 and 1935, the following books appeared from two publishers in two series titled "Deutsche Lande/ Deutsche Menschen" ("German Lands/ German People") and "Deutsches Land/ Deutsches Volk" ("German Land/The German People"): *Die Eifel*, *Das Siebengebirge* (*The Seven Hills*), *Die Saar* (*The Saar*), *Die Mosel*, *Bergisches Land* (*The Bergisch Land*), and *Am Nieder-*

umes, but only two actually appeared: *Die Eifel* (*The Eifel*) and *Die Mosel*, the latter of which was a 607-page survey with 117 prints. The next volume would surely have been the highlight of the series, since it was going to be dedicated to the section of the river that was most famous and beloved by tourists: the Middle Rhine. Mathar had invited Sander to collaborate on this volume, but for unknown reasons nothing came of this plan. This cannot have been due to either Mathar or Sander, for both continued to diligently write and photograph. A second collaborative project also failed. After his successful book on Italy, *Primavera* (1926), Mathar planned along with Sander

rhein (*Along the Lower Rhine*). Olivier Lugon, who has established new footing for the study of Sander and landscape photography, estimates the respective pictures to number a proud three thousand. We may therefore date the conception of this geographical and, in the broadest sense, Rhine-focused project to the time when the Rhineland was still occupied and efforts were made to continue work on the "ideology of the Rhine." This dispels the error I made in 1975 when I, acting on the memories of Sander's son, Gunther, interpreted Sander's landscape art as a withdrawal from and reaction to 1933, as a form of inner emigration and also as an answer to the impris-

onment of his son Erich, who, as we learned in 1999 with the publication of *August Sander: Landschaften* (*August Sander: Landscapes*), also produced, among other things, photographs of the Rhineland.

If we therefore assume a date of 1926, the question arises as to which consequences the region's political situation had for this landscape photography and whether a corresponding approach survived the "liberation" or was modified anew after 1930. An initial answer to these questions seems easy. Like Mathar, Sander experienced the Rhineland only as a whole and rejected all artificial new borders and jurisdictions—the only thing that counted was the river basin. And several attempts had been made to establish a "Rhine nation"; one of those attempts failed in Sander's beloved Seven Hills. We do not know where the photographer stood in relation to these plans and the likewise fiercely discussed issue of Prussia's connection to

the Rhineland. But through his own means, Sander did create this "Rhine nation," not only collecting pictures of numerous regions, but also providing a form of autonomy to the inhabitants, which elevated the "residents of the occupied regions" to the "people of the twentieth century."

Sander's Portfolio *Der Mittelrhein* for Hans Ludwig Mathar

When it came to choosing his illustrations, Mathar was satisfied with quite conventional answers. There is essentially no difference between his choices and the images from books on cities and landscapes that appeared before the war. This type of photography is very difficult to describe. A distinctive characteristic is the tendency to depict the "total" scene, as it was called—the opposite technique was named *partie* (figs. 7 and 8). The camera remains at a distance, regardless of subject matter. Even the widest shot seems to become even wider, and whatever is directly before the camera seems curiously to recede. Equally prevalent is the famous technique of *repoussoir*: a portion of a tree, cliff, or figure anchors the foreground, but only so that the distance can appear even more unreal. Almost all of these photographs were taken without the use of a viewfinder, and one can perhaps imagine how remote the future picture appeared on the photographic plate. One could be more aggressive with a viewfinder and shoot with more confidence, but that did not mean that one actually did that after a long familiarity with the plate camera or that Sander, who worked with plates, essentially accepted a similar distancing and drifting away in his scenes as part of the technique. A glance at the shot *Burg Rheineck* (*Rheineck Castle*) (fig. 8) provides an example of how one could ruin a typical motif. Mathar reproduced this image in the monograph *Kreis Ahrweiler* (*The Ahrweiler District*), which served as a small replacement for the unrealized volume *Der Mittelrhein* and with which he came close to Sander's preferred motifs.

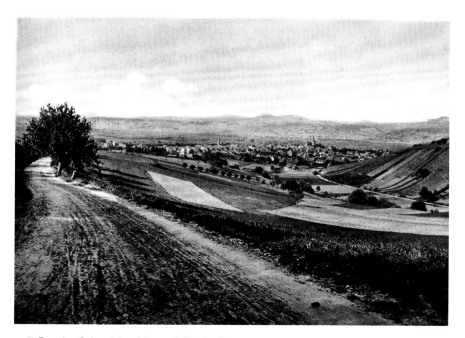

7. Baptist Schneider, *View of Sinzig*, from Hans Ludwig Mathar, *Kreis Ahrweiler* (Remagen: Kollbach, 1927)

What has gone wrong here is clear: the photographer wanted the partial cartouche created in the foreground by the tree and hill, but by the time he achieved that effect, he had lost his main subject, the beautiful round hill with Burg Rheineck, which has now sunk below the horizon along with all of the other elevated areas in the landscape—forcing the *repoussoir* to help stand in for the character of this mountainous landscape, while the horizon defines the total scene without communicating any of its content or the engagement between the river and the hill range. But let us not complain about the fact that the Rhine appears only in sections; Sander used a similar approach, as can be seen in plate 12 of this book: the famous "four lake view" at Boppard.

Truly, the photographic approach to people and places needed a makeover. What was in the portfolio that "August Sander, Sculptor of Light" gave to his friend, a work upon which was inscribed in a sans-serif font "Der Mittelrhein. Aufnahmen zu einem Kulturwerk von Dr. Ludw. Mathar, in Verehrung gewidmet Weihnachten 1926" ("The Middle Rhine. Photographs for a cultural work by Dr. Ludw. Mathar, dedicated with veneration, Christmas 1926")? It contained work that might not have been disappointing for the original recipient but certainly is for us Sander experts: eleven images, primarily of monuments (the Electoral Palace and the Carmelite church in Mainz, for example; fig. 9), which are no different from the popular style of monument photography seen in tourist guides—taken from a safe distance, often from an angle. Sander came into his own with portrait and landscape photography, but not with the photography of historical monuments. A foregone conclusion is that his abovementioned photography books also contain such images of architectural monuments, photographs in a style that fluctuates precariously between objective (in an art historical sense) and just plain touristy. Let us assume that Mathar desired something safe like this when he stipulated that the photographs should "capture the greatness of Rhenish culture in artistic images" and emphasized that they should "absolutely" have

"lasting significance." One of the images (fig. 10) is dramatically un-Sanderesque: the Alte Burg (Old Castle) of Leubsdorf stands in the background, and in the foreground are two young wanderers, one of whom stands with his back to the viewer, while the other, turned to the side, looks at us. This is naturally reminiscent of Sander's most famous photograph, *Drei Jungbauern auf dem Wege zum Tanz* (*Three Farmers on the Way to a Dance*). The men in this latter photograph, however, are not simply decorative but rather serve as a portrait of movement, as if they had been naturally placed so. But in the photograph for Mathar, everything is wrong, including the undefined proportions between the figures and the monument, but especially the strangely wooden nature of the arrangement. To introduce an idea we will discuss in more detail later: for Sander, everything came down to the symbiosis between humans and the landscape, but here we sense his intention yet feel let down.

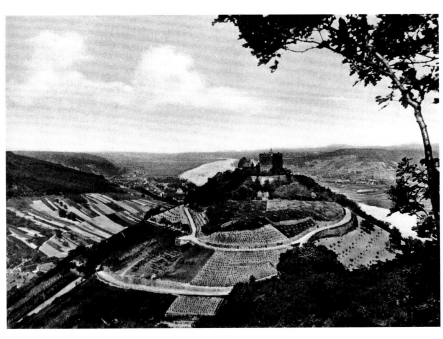

8. Baptist Schneider, *Rheineck Castle*, from Hans Ludwig Mathar, *Kreis Ahrweiler* (Remagen: Kollbach, 1927)

9. August Sander, *Electoral Palace in Mainz*, circa 1926

10. August Sander, *Leubsdorf at Linz, Alte Burg*, 1926

That said, two images from the portfolio for Mathar are completely different and will have an impact. As if he were no longer trying to enliven the scenery with strolling young men, but rather wanted to bring life to the Rhine itself, Sander shot two pictures from the deck of a steamship (figs. 11 and 12)—and "shot" is the right word for these images, since Sander did not normally take photographs in such a manner. One is titled *Der schlafende Strom* (*The Sleeping River*), while the other is named *Der singende Strom* (*The Singing River*), and the surface of the water moves accordingly—leaden gray and sluggish in the former image, while in the latter we see the movement of the wake, laced with reflective light. Photographing the Rhine from the Rhine (or at least from a position that hides his place on the edge) is something that Sander will repeat (see plates 1, 6, 11, 16, 17, 29, and 30). Such studies that are so close to their subject matter belong to an approach

to landscape photography that favors the scene's geological, botanical, and meteorological constituents: see the geological studies in this book (plates 19–26) and the numerous photographs with a lively sky—what is missing are Sander's brilliant studies of trees or samples from his portfolios with titles like *Die Flora eines rheinischen Berges* (*The Flora of a Rhenish Mountain*) or *Das Siebengebirge, Flora-Fernsichten* (*The Seven Hills: Views of the Flora*). In a 1931 radio speech, he alluded to the possibilities of an "exact landscape photography" that could serve the sciences, whose focus on geography, geology, botany, and meteorology was also important for the field of landscape photography, a branch that had first established itself artistically during the time of Sander's training via a focus on impressions. Impressions are certainly the opposite of the "exact," but they do belong to the fundamental appeal of a landscape—something not even Sander denied (see plates 1,

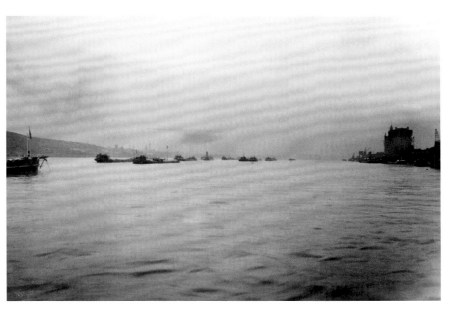

11. August Sander, *The Sleeping River*, 1926

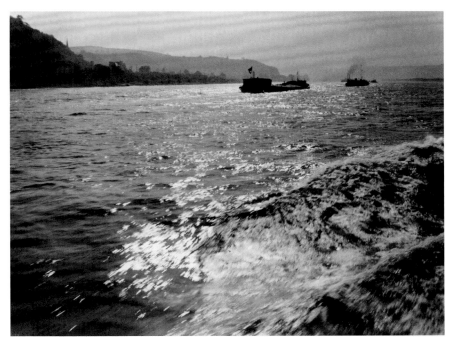

12. August Sander, *The Singing River*, 1926

2, 3, 6, 11, and 16)—where emotional images must not only display conventional values like sweetness or drama but must also represent a completely normal "day in the life of nature," as I mentioned in the first edition of this book.

August Sander and Franz M. Jansen: Painted Photography—
Photographed Painting

The 1926 portfolio marks an uncertain approach that is partly conventional and partly experimental. Much changed after that portfolio, and even within it we find the future road down which Sander will go, which leads to some of history's most famous landscape photography. The motivation to take this path came from another friend, the Cologne painter Franz M. Jansen (1885–1958). Among Sander's many painter friends,

Jansen was the one to whom he entrusted the painting of his home's staircase and studio. Like Mathar, Jansen was a regionalist.[25] He practiced a tortured expressionism until approximately 1925, when he converted convincingly and naturally to New Objectivity. He first mixed in elements from De Chirico—as did many from Cologne (refer back to Räderscheidt)—but then began specializing completely in Rhine landscapes, a topic that he explored in five portfolios of etchings from 1913 onward, and which he treated in a completely different style until 1925. Sander, who photographed many fellow artists' work for reproduction purposes, also served in this function for Jansen and was therefore thoroughly informed about his colleague's plans and stylistic options. Proof for Molderings and Heusinger von Waldegg's argument that the painter influenced Sander can be seen directly with the Rhine landscapes. In the portfolio are three reproductions of Jansen's

15

drawings of river landscapes from the Middle Rhine region (figs. 13 and 14). How they became part of this portfolio is difficult to say. Perhaps Sander wanted to help promote his friend. It could also be the case that Mathar, who engaged both artists and photographers for his volumes' illustrations, inserted the drawings among the photographs once the book project had advanced further. Jansen's views differ from Sander's early work in that they are neither fixated on monuments nor conceived with the river in mind; instead, they emphasize the bends in the river and the streets and train tracks accompanying it. The current itself remains literally underexposed.

The curious thing about these drawings is that they do not yet show the mature style of landscape art for which Jansen quickly became known, and which kept him above water, so to speak, for the rest of his life. Around 1925/26, he not only transcended expressionism but also distanced himself again from his New Objectivist Metaphysical Painting. While on long excursions, he captured Rhenish landscapes that, in contrast to Sander's quite dark reproductions, seem to be drawn in silverpoint. These landscapes accentuate the linear element and, through it, the energetic nature of the river and the trains that he added to the landscape. What links the photographs and the drawings in the 1926 portfolio is the relative compactness of the depicted objects. This way of treating the material says, quite simply: This is our own, it belongs to us, and it imposes a "demand for lasting significance," to quote Mathar once again. It can also be understood as a reaction to the occupation-era relationship of people to their property, a relationship based on restrictions and vulnerability: this is about safeguarding one's possessions. Yet emptiness is still prevalent; to oppose it, one must resort to adding travelers.

From 1926 on, Jansen developed a different approach

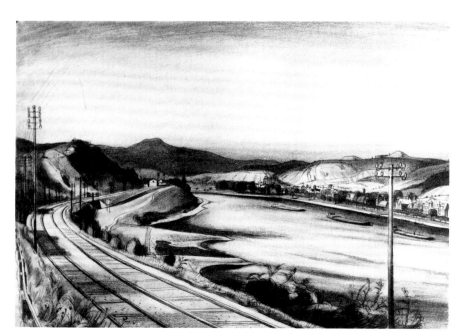

13. Franz M. Jansen, *Middle Rhine Landscape*, pencil drawing, 1926, reproduction photograph by August Sander

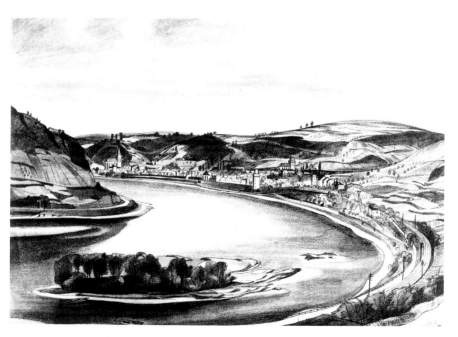

14. Franz M. Jansen, *The Rhine at Erpel*, pencil drawing, 1926, reproduction photograph by August Sander

(though not necessarily in relation to emptiness), and because he used this approach in drawings of the Middle Rhine, we may assume either that he had received a larger commission for the Middle Rhine book or that he simply decided to carry on, far past 1926, not even stopping during the Third Reich. In fact, such a regionalist would have been in great demand, and immediately after the Nazi takeover Jansen received an assignment to decorate the university in Cologne with a large (now destroyed) picture under the motto "Deutscher Mensch in deutscher Landschaft" ("The German in the German landscape"). This happened after he had won a first-place prize for his sketch *Deutsche Rassen* (*German Races*). Contracts followed from the military and the city of Cologne, as well as the chance to participate in prominent exhibitions. Evidently, Jansen knew how to benefit from the new era—in contrast to his friend Sander, whose portrait volume *Antlitz der Zeit* was removed from the market, the printing plates destroyed, and whose life's work, *Menschen des 20. Jahrhunderts*, now had no chance of being published.

But back to the year 1926. Mathar's failed Middle Rhine project very likely provided the impetus for two other artistic projects, one spurred on by the other and both becoming effectively autonomous in the sense of giving the Rhineland a new visual style. Additionally, it is probable—though not known for sure—that Jansen occasionally worked from photographs by Sander after both had agreed upon a suitable type of framing. Included as part of Sander's estate is a letter from 1927 in which Jansen, with the assistance of a drawing, sought one of Sander's photographs.[26]

This framing was based on the panorama,[27] an escalation of the technique of capturing the "total," which clearly goes beyond the Jansen landscapes in Mathar's portfolio: in its play with the linear, the panorama is bound—though not necessarily subordinate—to the horizon. If we lay the abovementioned photograph of Burg Rheineck (fig. 8), which already attempts to show a "totality," next to Jansen's and Sander's images of

the Rhine at Boppard (figs. 15 and 16), then we might comment on how the picture of the Rhine landscape seems to come to life. We have two "epic" landscapes, which are not dramatic, not engineered, and cohesive, and which fundamentally achieve the most difficult task for any picture of a fragment: they evoke an entirety. These are representations of the Rhineland that, even individually, speak to the whole, a goal that Sander and Mathar strove to achieve additively with numerous texts, illustrations, and projects focused on partial aspects. And to note again without great fanfare: the epic landscape is also a reaction to the land's occupation, and we could discuss at length whether this artistic breakthrough of 1926 coincided with the region's first step toward "liberation," which, as we have already noted, began with the British withdrawal from Cologne in that same year. Think again about the regional and national synchrony that established itself as the radio first reached the people in the Rhineland, as well as all other Germans, and broadcast the bells of the "liberated" Cologne Cathedral. After 1945, Germany was occupied for so long that this condition somehow became part of German national consciousness. But in 1926, the Germans still lacked this practice, and the occupation strongly shook the self-conception and self-image of the nation. As the last occupying forces left the Rhineland in 1930, Sander provided seventeen images for the volume *Der Rhein ist frei* (*The Rhine Is Free*), which the *Kölnische Zeitung* published for its 125th anniversary. The article "Der rheinische Mensch" ("The Rhinelander") was illustrated with nine portraits, while other images encompassed pastoral scenes and landscape photographs, including a panoramic look at the Seven Hills; these hills dramatically accentuate the end of the article "Das Rheinland im politischen Schachspiel" ("The Rhineland in a Political Game of Chess"), where the author or the typesetter has turned the final words of the essay into a simultaneous title for the illustration: "Bringing peace to the world means, not least, bringing peace to the Rhineland. So, all you world powers, hands off the Rhineland! For

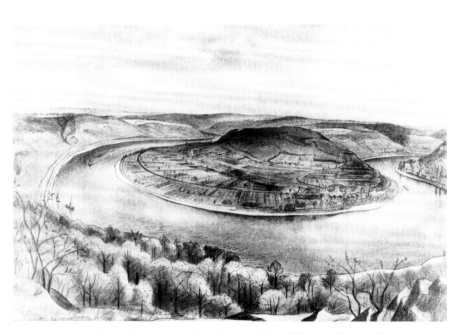

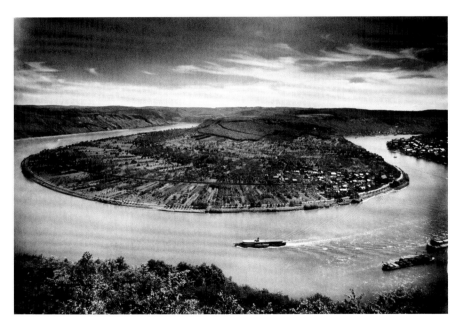

15. Franz M. Jansen, *The Curve of the Rhine at Boppard*,
pencil drawing, 1925

16. August Sander, *Curve of the Rhine at Boppard*, 1938

a requirement for any European policy of peace is *The Peace on the Rhine*."[28] The anniversary text also responds to the situation in the Saar region. The motto was "withdrawal from the Saar must come"—but that had not yet occurred as Sander published his illustrated volume on the Saar region, a circumstance that he denounced in his preface. In the preface to the volume *Mosel*, he followed Mathar's lead, discussing in detail the fortress Montroyal and dedicating to it two illustrations, which, considering the book's short length, is noteworthy. Instead of showing the remains of the fortress, however, both photographs display high panoramas over the river and a wide land bordered only by the horizon.

Let us return once more to the pictures of the bend in the Rhine at Boppard. Both Jansen and Sander have rejected here the *repoussoir* approach. An effect of depth is created by the course of the river, which appears from out of the distance and then disappears back into it after making a perfect curve in the

foreground. Now the hilly, elevated portion of land lies in the center of the circular shape under the horizon, matching what we saw—and criticized—in figure 8. Yet we notice that with Sander's and Jansen's works, no peak stands out, for both artists have approached this landscape, both here and in many comparable images, from a completely different viewpoint: the theme is neither hill nor valley, nor anything to do with depth, but rather breadth, expansion, and spaciousness. This is a generous landscape that expresses itself essentially in the linear, not in relief. The horizon is therefore perhaps the most important, but certainly not the only line, a first among many others repeated in the border between the clouds and the light; in the contours of the riverbank; in the movement of the ships and their wakes; and even in the river itself, whose liveliness appears in the wake zone of Sander's image, although the river's flow is only indirectly visible through the large curve. This curve provides something like a sense of acceleration,

especially—and here I am speaking only about Sander's work—with the framing of the water, which cuts off portions to the left, to the right, and in the foreground. The result is that the viewer senses in the river a drive that erodes or submerges the natural and artificial borders of the format, particularly in the foreground. We are reminded again of Sander's memories of a similar situation: "Here, before my eyes, was a panorama of unbelievable beauty. And breaking through the prevailing stillness to reach me was the eternal sound of the rushing Rhine."

We must still address the matter of emptiness in Sander's work. In a sense, his Rhine landscapes are not empty at all: easy to read, they are full of traces of human appropriation of the landscape or the natural forces that created it. These photographs have been associated with the concept of the *Erdlebenbild* (a depiction of the world evoking the artist's own experienced relationship to it), which the romantic Carl Gustav Carus recommended for landscape painting. In the introductory essay for the first edition, I compared them somewhat more simply to vacated factory yards of culture and nature. A large difference therefore exists between the emptiness of Sander and the nihilistic emptiness of Räderscheidt and many other Cologne painters of the 1920s. Sander cultivated an emptiness with history and expectation, which means that the "silent" and "bare nature" to which Kracauer reduced the scope of photography during this period simply does not apply. And yet, it seems incomprehensible that one could take those countless landscape photographs without the physical presence of human beings. Even the monuments, villages, and cities that Sander included in photographic form in his art books remain lifeless. The traveling young men are unemployed. Two possible explanations for this emptiness present themselves. The first is that Sander wanted to maintain purity within his genres: on one side, he practiced "exact photography" (his words) of people, and so on the other side, he created equally exact, pure landscapes. We could also refer to the conventions of New Objectivity, which was developing at the very moment that Sander began his systematic treatment of landscape photography. No people appear in Renger-Patzsch's photographs, either. But I am of the opinion that these trends, both undoubtedly relevant, can be supplemented with, if not replaced by, a specifically Rhenish explanation. As Renger-Patzsch moved to the Ruhr region toward the end of the 1920s, the area had already undergone such a massive process of modernization that hundreds of coal mines had closed, and between 100,000 and 200,000 miners had lost their jobs. Logically, then, Renger-Patzsch photographed an industrial landscape that tended to work in a fully automated fashion. The absence of people can reflect more than just a stylistic choice, and this also held true for the artists of the Rhineland. The sense of being dispossessed despite all efforts, a feeling we discussed earlier within the context of the "lament on the Rhine," appears to have lasted, indeed to have extended, into the time of the Rhineland becoming freer piece by piece. During that period, Sander and Jansen developed an artistic concept that brought the Rhenish landscape together under a broad common denominator and, in a sense, expanded the landscape's boundaries.

August Sander's Photography Books

With such a large number of undated prints, determining when Sander turned to his Jansen-influenced approach—when the panorama began corresponding to the pan-Rhenish—is as good as impossible. The photographs that Sander contributed to calendars, newspapers, and books from 1930 on were, as a rule, probably selected by editors and authors who were still comfortable with the old style—something of which Sander was a master, as he did, after all, live off of the sale of his work. We can only make a judgement in cases where he himself chose the images and their sequence; this criterion elevates the importance of his six booklets, as he

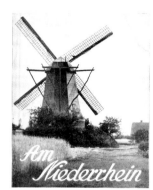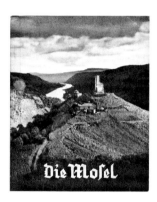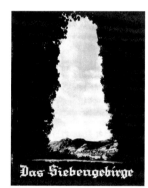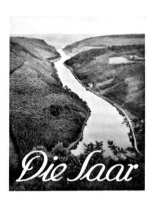

17. The covers of the six illustrated books by August Sander, 1933–1935

illustrated them with prints taken from 1926 onward and supplied them with his own introductions (with the exceptions of *Die Saar* and *Am Niederrhein*, the latter of which contains an introduction from Mathar). Here, we can be relatively certain that Sander could set his own priorities, including those related to design (fig. 17). The volume *Siebengebirge*, distinctly devoted to his favorite landscape, offers an eye-catching cover in the style of touristic photography: a view through the Rolandsbogen castle ruins. While this view appears in a downright forced portrait orientation, after that, the reader must simply rotate the book ninety degrees to take another look at the same setting, to see panoramas of the Rhine, Seven Hills, and Drachenfels in a format that holds until approximately Plate 8. Many images correspond perfectly to Jansen's schema (see the earlier discussion of Fig. 15), especially with Sander's attention to energetic, linear forms. In the tenth illustration, the Drachenfels appears as a close-up portrait, but afterward, panoramic views dominate through the thirteenth illustration. Tourist sites, churches, and castles follow, faithfully captured like the monuments in the portfolio for Mathar. Finally, we also see two portraits, one of a farmer and one of a winemaker from the region. Sander does not yet go as far as can be seen with plate 33 of this book (fig. 18): such a zen-gar-

den version of the Seven Hills, this singularly high degree of abstraction almost anticipating minimalism, either could not be conveyed or had simply not yet been achieved. But in any case, we can see Sander developing his Jansen-influenced approach further along these lines, even moving beyond it toward a symbolic system of the landscape. It certainly would not be saying too much to note the level of landscape appropriation that became possible after the phase of securing the Rhineland's identity (refer back to the Mathar portfolio) and the rise of a border-dismissing, pan-Rhineland ideology (refer back to Jansen's and Sander's image of the Rhine's curve at Boppard). At the same time, while the beautiful photograph in plate 31 of this book, also reproduced in the Seven Hills booklet, hints at Sander's new direction, the image also shows a lingering interest in a scale-model reproduction of the curved street.

The selection of images in this book covers a range of material that Sander was unable to add to his Seven Hills volume, in particular the geological studies belonging to an "exact photography." We should note here that Otto Brües, a tireless promotor of Jansen's work, said of his form of landscape art after the war that he had "fused the 'knowledge' of today's Rhine with its appearance—knowledge insofar as he has depicted

the Rhine in its characteristic elements and with a pronounced sense of the geological, the growth of a landscape."[29] Now, unlike other regions around the Rhine, the Seven Hills range is a nature reserve and is therefore not characterized by traffic, industry, or the production of raw materials (with the exception of stone quarries). Even so, Sander was able to bring his cultural geographic approach to bear both here and in his representation of other landscapes.

As Sander provided an update on his projects in a 1925 letter to photography historian Erich Stenger, he referenced, in addition to his portrait work, a "parallel portfolio" that along with "the individual classes" of society would also capture "their surroundings via absolute photography" and thus "the evolution from a village into a modern metropolis."[30] Sander expressed himself similarly in the fifth of his 1931 radio speeches on photography (not yet published, unfortunately), when he said, "Now that we have charted human physiognomy, let us turn to human creations, that is, to the works of humankind. We shall begin with the landscape. Here, too, humans have made their mark through their efforts so that the landscape emerges, just like speech, from necessity—see how humankind has altered in this manner biological developments. Furthermore, we can again recognize in the landscape the human spirit of an era, a spirit we can now capture thanks to the camera."[31] And with this, we are addressing Sander's abovementioned second impulse for turning to landscapes. The assignment from Mathar and collaboration with Jansen underpinned one impetus, while the other came from, of all things, Sander's deliberations over the nature of his project *Menschen des 20. Jahrhunderts*. Sander's focus on the formative power of work, the career, meant that he needed to make at least a token effort at providing context. But of course, he determined rather quickly that he would be unable to properly incorporate "the works of humankind" and their world-shaping power. And so he thought of a parallel project that would be called "Mensch und Landschaft im 20. Jahrhundert" ("Humankind

and the Landscape in the Twentieth Century")—quite a title for the postwar period. This "chronologically comprehensive picture of the earth's inhabitants" did not go particularly far in the sense that it eventually dissipated into numerous portfolios that were constantly being supplemented and rearranged. Sander liked to call these "cultural portfolios," and he pitched them to such potentially interested parties as district offices, regional culture associations, and publishers.[32] But a firm plan, such as the one he kept on hand for his project *Menschen des 20. Jahrhunderts*, likely did not exist. Now and then, third-party references to his intentions or similar reports surface announcing a work on "humankind and the landscape," "in which he [Sander] will attempt to depict the unity between types of people and nature."[33] This artistic program accomplished two things: it allowed his intensive landscape work to appear

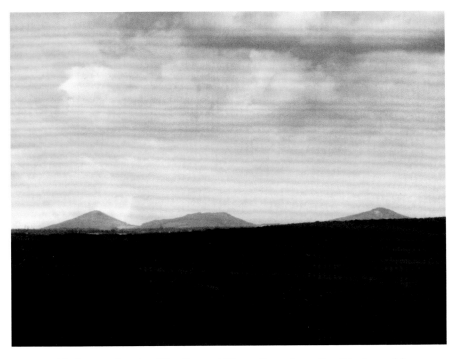

18. August Sander, *The Seven Hills as Seen from the Westerwald*, after 1926

without being completely detached from his portrait work, and it helped maintain his hope for a great synthesis of life. It also left behind at least rudimentary traces in his six art books, which do contain several portraits of people from their respective regions. The plates, located in general at the end, offer typically Sanderesque representations of farmers and craftsmen, including truly magnificent images that, for some reason, never made it into the portfolios of the main work (fig. 19).

In looking at "humankind and the landscape," Sander followed a cultural geographical approach that, while topical in his time, had been practiced essentially since the Enlightenment. According to it, the physiognomy of a landscape could supposedly be located in the physiognomy of its inhabitants, and vice versa. With his second great project, Sander would have fit right in with the field of Rhenish regional history, a discipline that was establishing itself at that very same time. In his breakthrough work, the habilitation thesis *Studien zur westdeutschen Stammes- und Volksgeschichte* (*Studies in West German Ethnic and Folk History*) (1925), for example, Franz Steinbach undertook a comparative study of farmhouse structures, dialects, and place names. So why not look at the physiognomies of typical Rhinelanders or their historical representations? In his volume on the Lower Rhine, Sander persuasively compared the portrait of a "contemporary person from the Lower Rhine" to a man's face from a seventeenth-century altar to prove that modern humans had "not changed one bit." Yet Sander the physiognomist could not actually demonstrate with such a face

19. August Sander, *Farmer from the Rhenish Highlands*, after 1926, from August Sander, *Das Siebengebirge* (Bad Rothenfelde: Holzwarth, 1934)

"how it was marked by the landscape of the Lower Rhine." He could only note, "One could hardly imagine this face in the mountainous landscape of the Alps." But that would have definitively proven the point of the whole "humankind and the landscape" project. At any rate, a clear distinction still existed between this kind of approach and a bloodline-based racial or ethnic theory, but a pathway had suggested itself, and for that reason Steinbach and his institute strictly refused to allow any inquiries in this direction—at least until 1933. It is interesting to see that Sander, in his preface to the volume *Siebengebirge*—note that this is from the year 1934!—discussed for the first and only time the concept of the *Volk* and explored the ethnic history of the people from the Seven Hills. They were classified under the Ripuarian Franks, "one of the most culturally powerful clans" and the "most gifted in form of all of its brothers." "[S]o the harmony between nature and culture that one finds even today in the Seven Hills is thanks to the intuitive might and artistic sense of the Ripuarian Franks."[34] Such harmony, however, was also to be found in the interplay between the people and nature of other regions, and, though reluctant, Sander was ultimately consistent enough to place the well-established inhabitants at the end, and not at the beginning, of his landscape books (except for in *Die Saar*) and keep the portraits free of details that would locate the subjects within their environment. He offers us pure physiognomy, and we, who are no longer versed in physiognomy, stand perplexed before the question of how the environment

or one's ethnic history could have possibly stamped, or indeed produced, such specific characteristics. Possibly not even Sander's contemporaries could have answered this question. And thus we may consider Sander's inclusion of the portraits and their placement at the end as a matter of duty, as a concession to the spirit of the times, but also as a concession to his own highly demanding attempts at a "chronologically comprehensive picture of the earth's inhabitants."

Though Sander's other project, *Menschen des 20. Jahrhunderts*, lagged behind as infinitely expandable, it did have a basic framework. His work on "humankind and the landscape" would later become partially incorporated within it in curious portfolios such as "Die Straße" ("The Street"). In the volume that Sander dedicated to the Lower Rhine, and which contains Mathar's foreword, the photographer moves very quickly past Europe's largest industrial region and essentially shows just one relevant picture. In an introductory note to the book, Sander speaks again about the agreement (already discussed above) between the modern Lower Rhenish people and their ancestors' artistic representations. He then says, "On the other hand, industry, through its newly created relations, has minted a new type of person, one who has barely anything do to with the landscape." With this, Sander shows himself justified in seeing the "people of the twentieth century" as representatives of a profession. He also demonstrates the landscape connection as a possible criterion for his first portfolio, the famous "Stamm-Mappe" ("Family Portfolio") that Sander devoted to people from the farming environment, and into which he added numerous prints from the prewar period. The entire *Menschen des 20. Jahrhunderts* project, however, was supposed to represent society in seven groups with forty-five subsections, and Sander had not arranged such divisions for his second project. But his photographic landscape work clearly proves that even with this genre, he aimed for totality and variety; sought, in a sense, to create geological and botanical "family portfolios"; and studied the city, land, and river in their

most multifaceted permutations and moods in order, finally, to "praise" the image's vicissitudinous sky. He met all expectations, but one has the feeling that he returned from each of his countless expeditions with photographs that say, "None of us knew Germany." We could say the same about the Rhineland.

I thank Lothar Schirmer of Munich and Tanja Löhr-Michels, librarian for the photography collection at the SK Stiftung Kultur in Cologne, for their support.

Notes

1. Herbert Molderings, review of *August Sander Rheinlandschaften*, with an essay by Wolfgang Kemp, *Kritische Berichte* 3, no. 5/6 (1975): 120ff.; Joachim Heusinger von Waldegg, *Gemalte Fotografie—Rheinlandschaften*, catalog (Bonn: Rheinland-Verlag, 1975). Important since then: *August Sander: Landschaften*, with an essay by Olivier Lugon (Munich: Schirmer/Mosel, 1999); *August Sander—Franz M. Jansen: Rheinlandschaften im Dialog*, catalog (Bonn: Verein August Macke Haus, 2002).

2. Anne Ganteführer-Trier, "Zeitgenossen," in *Zeitgenossen: August Sander und die Kunst der 20er Jahre im Rheinland*, catalog (Göttingen: Steidl, 2000), 27.

3. Siegfried Kracauer, "Soziologie als Wissenschaft," in *Schriften*, vol. 1 (Frankfurt am Main: Suhrkamp, 1971), 13f.

4. Siegfried Kracauer, "Deutscher Geist und deutsche Wirklichkeit," in *Schriften*, vol. 5, 1 (Frankfurt am Main: Suhrkamp, 1990), 151ff.

5. Ibid.

6. Siegfried Kracauer, "The Biography as an Art Form of the New Bourgeoisie," in *The Mass Ornament: Weimar Essays*, trans. and ed. Thomas Y. Levin (Cambridge, MA: Harvard University Press, 1995), 102. Published in German as "Die Biographie als neubürgerliche Kunstform" (1930), in *Das Ornament der Masse* (Frankfurt am Main: Suhrkamp, 1977), 76.

7. Heusinger von Waldegg, *Gemalte Fotografie—Rheinlandschaften*, 11, with reference to Horst Richter, *Anton Räderscheidt* (Recklinghausen: Bongers, 1972), 14.

8. See "Die Jahrtausendausstellung in Köln" on the website *Rheinische Geschichte*. http://www.rheinische-geschichte.lvr.de/themen/Das%20Rheinland%20im%2020.%20Jahrhundert/Seiten/DieJahrtausendausstellungen-inKoelnundAachen1925.aspx.

9. Alfons Pacquet, "Der Dichter und die Gestaltung des Rheinstromes," *Frankfurter Zeitung*, July 27, 1927.

10. Josef Winckler, *Der Ruf des Rheins* (Cologne: Saaleck-Verlag, 1923), 30.

11. Josef Winckler, "Klage am Rhein," in *Rheinischer Beobachter*, 12 (1921), as cited in Gertrude Cepl-Kaufmann and Antje Johanning, *Mythos Rhein* (Darmstadt: Primus Verlag, 2003), 281.

12. H. A. Scheller-Noetzel (Arnolt Bronnen), *Der Kampf im Äther oder: Die Unsichtbaren* (Berlin: Rowohlt, 1935), 245.

13. Konrad Adenauer, speech in honor of the British evacuation of Cologne (January 31, 1926). http://www.konrad-adenauer.de/dokumente/reden/rede1.

14. Willi Oberkrome, *Deutsche Heimat : nationale Konzeption und regionale Praxis von Naturschutz, Landschaftsgestaltung und Kulturpolitik in Westfalen-Lippe und Thüringen (1900 1960)* (Paderborn: Schöningh, 2004), 99.

15. Josef Hofmiller, "Deutsche Reiseziele nach dem Krieg" (1915), in *Wanderbilder und Pilgerfahrten* (Leipzig: Rauch, 1938), 90.

16. Ibid., 91. I am preparing a study under this same name on the image of Germany held by Germans during the Weimar Republic.

17. Andrea Wetterauer, *Lust an der Distanz: die Kunst der Autoreise in der "Frankfurter Zeitung"* (Tübingen: Tübinger Vereinigung für Volkskunde, 2007), 59.

18. Alfred Döblin, "In den Alpen" (1924), in *Kleine Schriften*, vol. 2 (Olten and Freiburg: Walter-Verlag, 1990), 417.

19. August Sander's recollections cited in *August Sander: In der Fotografie gibt es keine ungeklärten Schatten!*, catalog (Berlin: Ars Nicolai, 1994), 195.

20. Ganteführer-Trier, "Zeitgenossen," 45. A listing of the WERAG issues to which Sander contributed from 1930 onward can be found in *August Sander: Landschaften*, 233ff.

21. Gertrude Cepl-Kaufmann, "August Sander und sein künstlerisches Umfeld: Die Schriftsteller," in *Zeitgenossen: August Sander und die Kunst der 20er Jahre im Rheinland*, 169 (according to a document from the REWE Library at the August Sander archive, photography collection, SK Stiftung Kultur, Cologne).

22. Ludwig Mathar, "Montroyal," in *Die Mosel* (Cologne: Bachem, 1924), here as cited in *Ludwig Mathar 1882–1958* (Monschau: Weiss-Druck und Verlag, 1982), 184.

23. *August Sander: eine Reise nach Sardinien*, catalog (Hannover: Sprengel Museum, 1995).

24. The photographer's estate is part of the photography collection of the SK Stiftung Kultur, Cologne.

25. Regarding the relationship between Sander and Jansen, see Heusinger von Waldegg, *Gemalte Fotografie—Rheinlandschaften*; and Ganteführer-Trier, "Hier bot sich meinem Auge ein Panorama von unglaublicher Schönheit," in *August Sander—Franz M. Jansen*, 11ff.

26. Reproduced in Ganteführer-Trier, *Zeitgenossen: August Sander und die Kunst der 20er Jahre im Rheinland*, 11.

27. For more detailed discussion, see Lugon in *August Sander: Landschaften*, 40ff.

28. Rolf Le Beau, "Das Rhineland im politischen Schachspiel," in *Der Rhein ist frei*: *Festschrift zum 125. Jubiläum der Kölnischen Zeitung* (Cologne: Verlag der Kölnischen Zeitung, 1930), 30.

29. Cited from Ganteführer-Trier, *Zeitgenossen: August Sander und die Kunst der 20er Jahre im Rheinland*, 15.

30. August Sander to Erich Stenger on July 21, 1925, Agfa Foto-Historama, Cologne, as cited in *August Sander: Landschaften*, 25.

31. August Sander, *Wesen und Werden der Photographie: Die Photographie als Weltsprache*, fifth speech for the West German Broadcasting Corporation, 1931, as cited in Ulrich Keller, *August Sander: Menschen des 20. Jahrhunderts* (Munich: Schirmer/Mosel, 1980), 28.

32. For more discussion of this parallel project, see Lugon, essay for *August Sander: Landschaften* (Munich: Schirmer/Mosel, 1999), 37ff.

33. *Kölnische Zeitung*, November 17, 1936, as cited in Werner Schäfke, "August Sander—die Mappe als offenes Kunstwerk," in *Kölner Museums-Bulletin* 2009, 66.

34. August Sander, *Das Siebengebirge* (Bad Rothenfelde: Holzwarth, 1934), introduction.

List of Plates

The titles and dates for several photographs differ from those given in the first edition of *Rheinlandschaften* from 1975. The following plate descriptions have been formulated based on new research and in consultation with the August Sander archive of the photography collection at the SK Stiftung Kultur in Cologne.

1. *View of Cologne at Sunrise*, 1938

2. *The Rhine behind Cologne as Seen from the Mülheimer Bridge*, 1936

3. *View of the Laacher Mountains from the Hohe Acht*, 1933 (Erich Sander for August Sander's studio)

4. *The Seven Hills as Seen from Rheinbreitbach*, 1935

5. *The Seven Hills from the Rolandsbogen to the Ölberg*, 1929/30

6. *The Seven Hills at Oberwinter*, 1930s

7. *View of the Island Nonnenwerth and the Eifel Mountains from the Drachenfels*, 1930

8. *View of the Island Nonnenwerth*, 1937

9. *View of the Island Nonnenwerth*, 1937

10. *View of the Rhine from the Erpeler Ley*, 1935

11. *The Rhine at Niederdollendorf*, 1930s

12. *The Four Lake View at Boppard*, 1938

13. *Curve of the Rhine at Boppard*, 1938

14. *The Rhine at Honnef*, 1930s

15. *Linz as Seen from Brück*, 1930s

16. *The Rhine at the Erpeler Ley*, 1930s

17. *View of Mondorf and the Seven Hills from Widdig*, 1930s

18. *The Marksburg at Braubach*, before 1933

19. *Clay Pit on the Mönchsberg at Godesberg*, 1938

20. *Basalt Quarry near Dattenberg*, 1935

21. *Basalt Quarry in the Seven Hills*, circa 1938

22. *Himbergsee in the Seven Hills*, before 1934

23. *Schwarzer See near Leubsdorf*, 1930s

24. *Pieces of Basalt at Schwarzer See*, 1930s

25. *Basalt Layers at Schwarzer See*, 1930s

26. *Basalt Quarry in the Seven Hills*, 1930s

27. *Drachenfels in Autumn*, 1930s

28. *View of the Rhine Valley from the Ölberg*, 1939

29. *The Rhine at Dormagen*, 1935

30. *Bingen in the Evening*, before 1926

31. *Heisterbach with the Ölberg in the Background*, before 1934

32. *Ölberg as Seen from Hasselbach*, 1930s

33. *The Seven Hills as Seen from the Westerwald*, after 1926

34. *The Seven Hills as Seen from Eichelhardt*, 1930s

35. *The Löwenburg Shrouded in Fog*, 1946

36. *View of the Löwenburg*, before 1934

37. *View from the Wolkenburg (Spring)*, 1937

38. *View from the Wolkenburg (Summer)*, 1930

39. *View from the Wolkenburg (Autumn)*, 1936

40. *View from the Wolkenburg (Winter)*, 1946

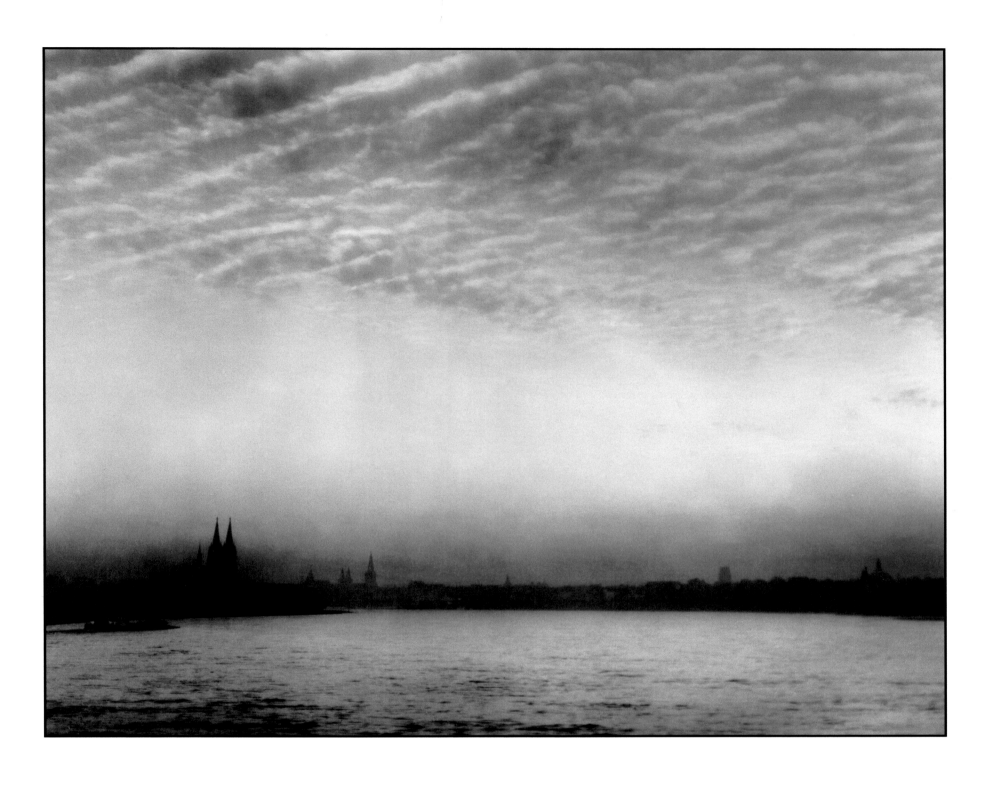

1. *View of Cologne at Sunrise*, 1938

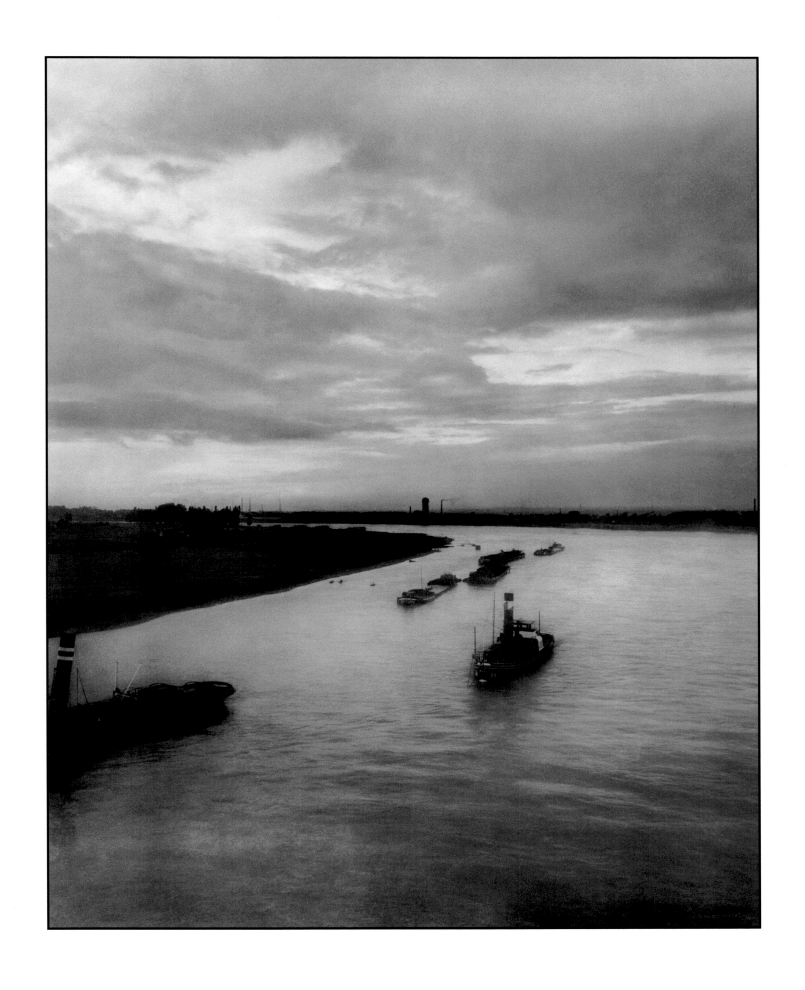

2. *The Rhine behind Cologne as Seen from the Mülheimer Bridge,* 1936

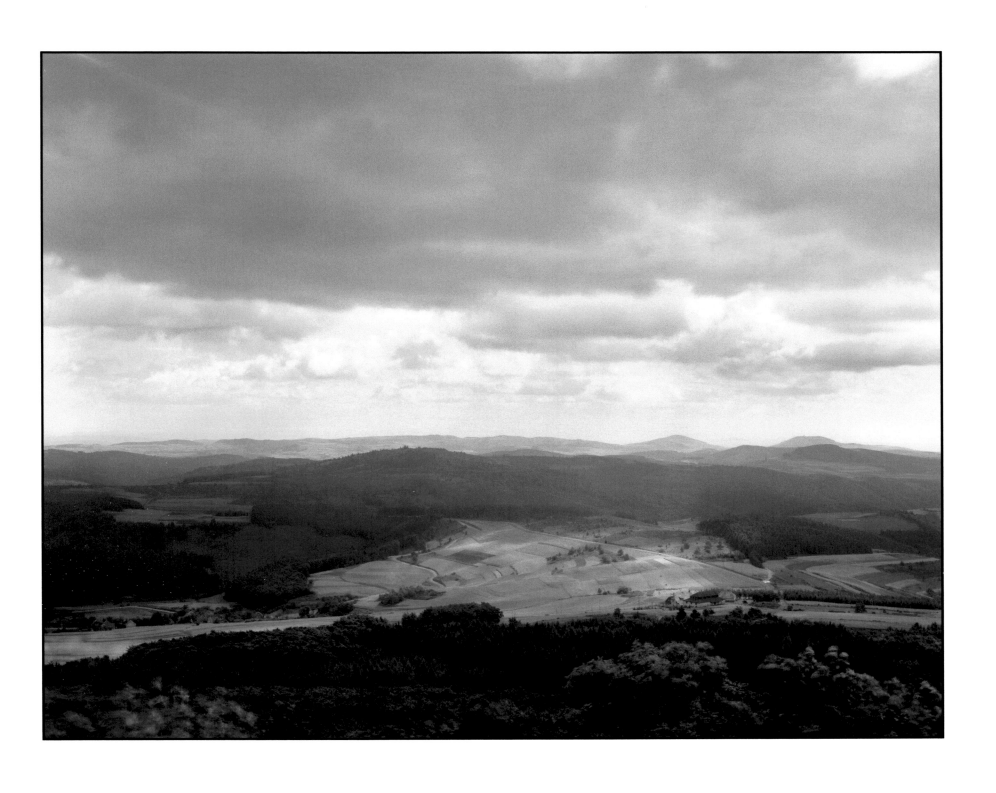

3. *View of the Laacher Mountains from the Hohe Acht*, 1933 (Erich Sander for August Sander's studio)

4. *The Seven Hills as Seen from Rheinbreitbach*, 1935

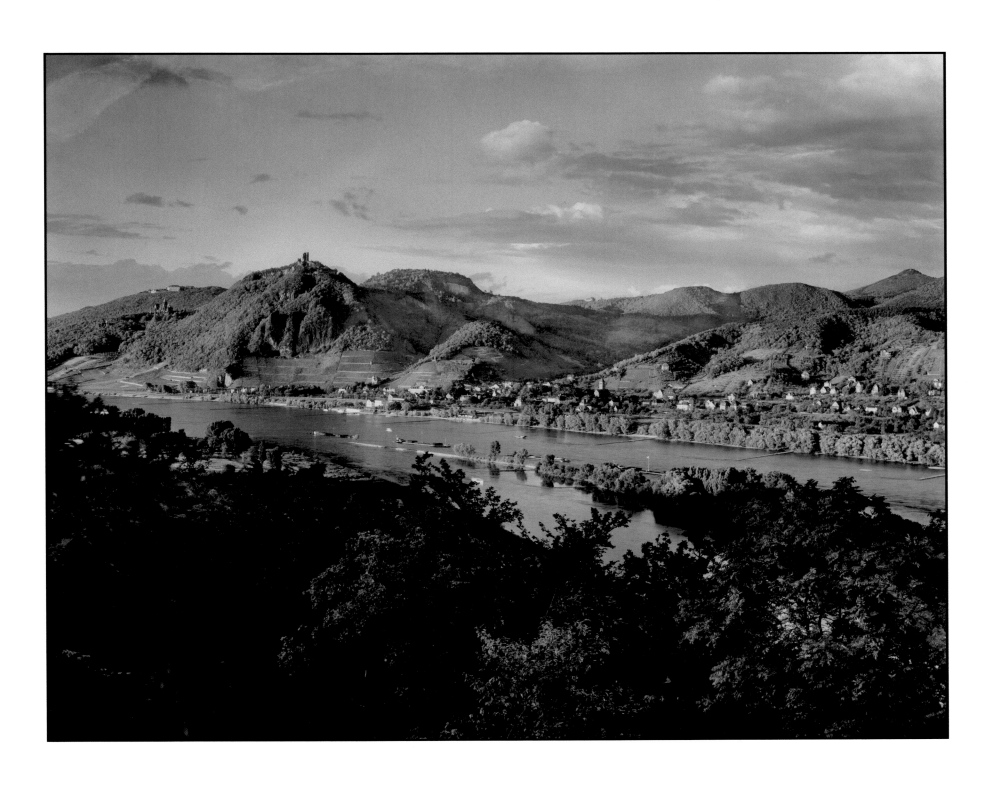

5. *The Seven Hills from the Rolandsbogen to the Ölberg,* 1929/30

6. *The Seven Hills at Oberwinter*, 1930s

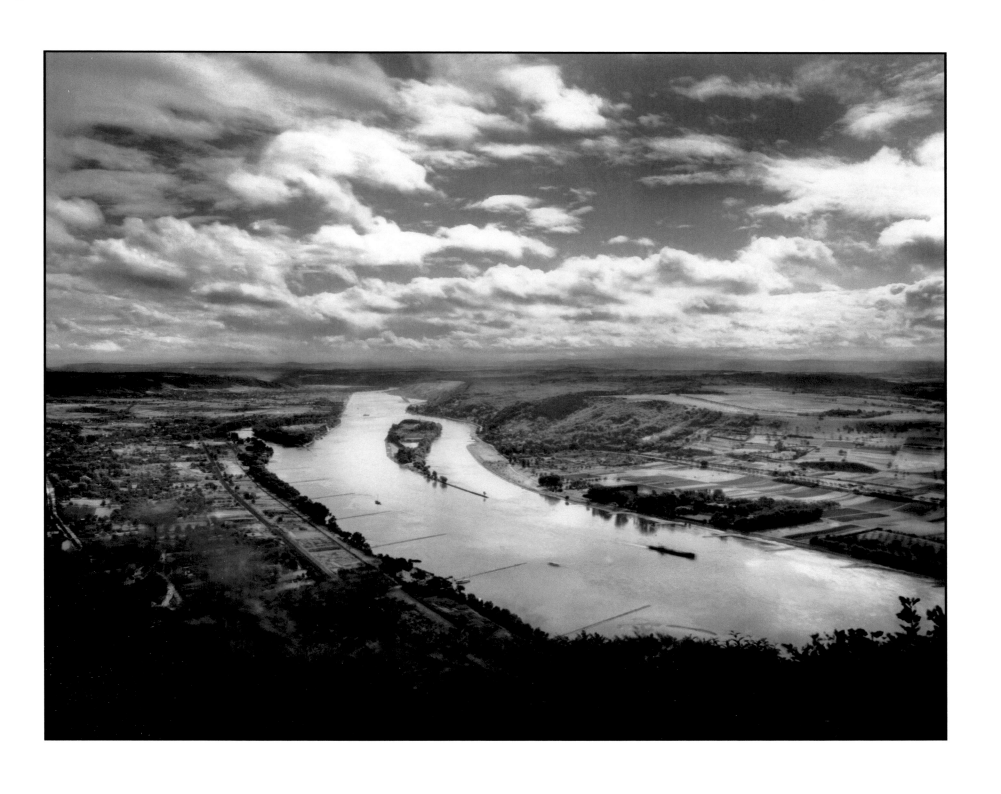

7. *View of the Island Nonnenwerth and the Eifel Mountains from the Drachenfels*, 1930

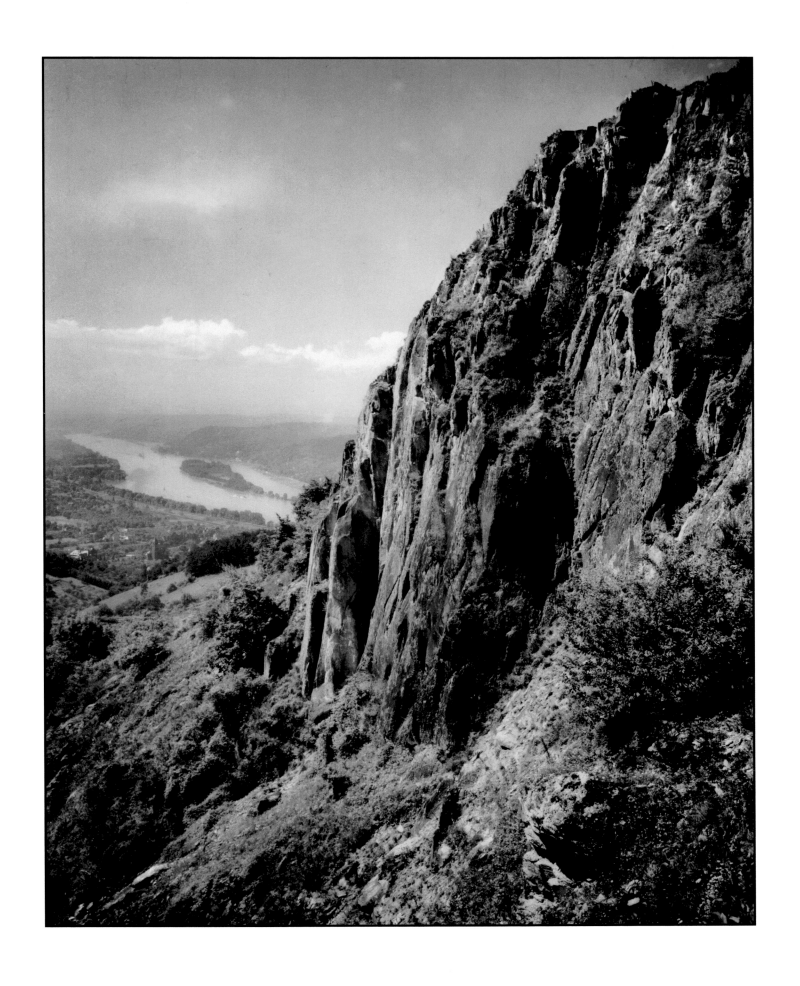

8. *View of the Island Nonnenwerth*, 1937

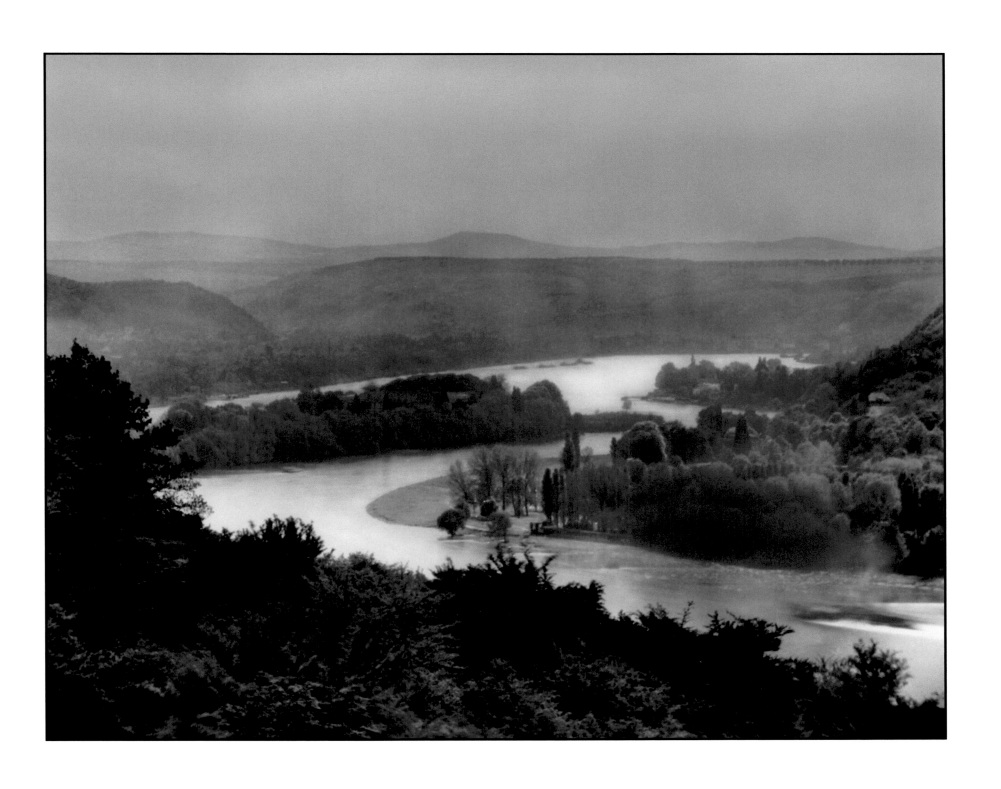

9. *View of the Island Nonnenwerth*, 1937

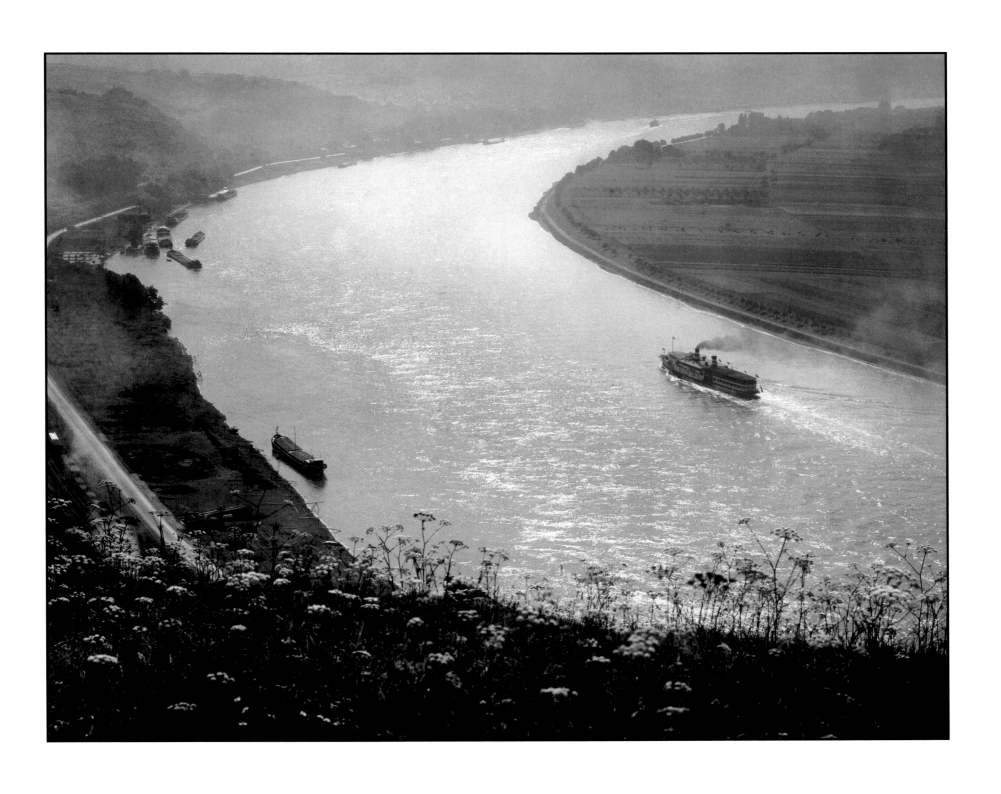

10. *View of the Rhine from the Erpeler Ley,* 1935

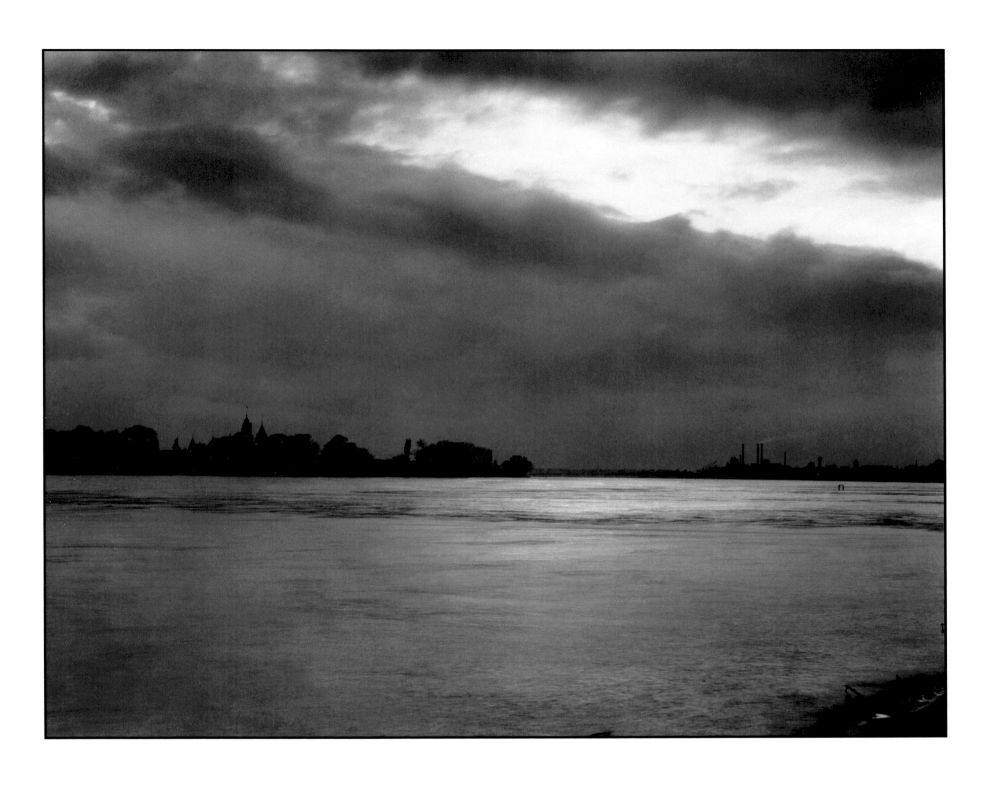

11. *The Rhine at Niederdollendorf*, 1930s

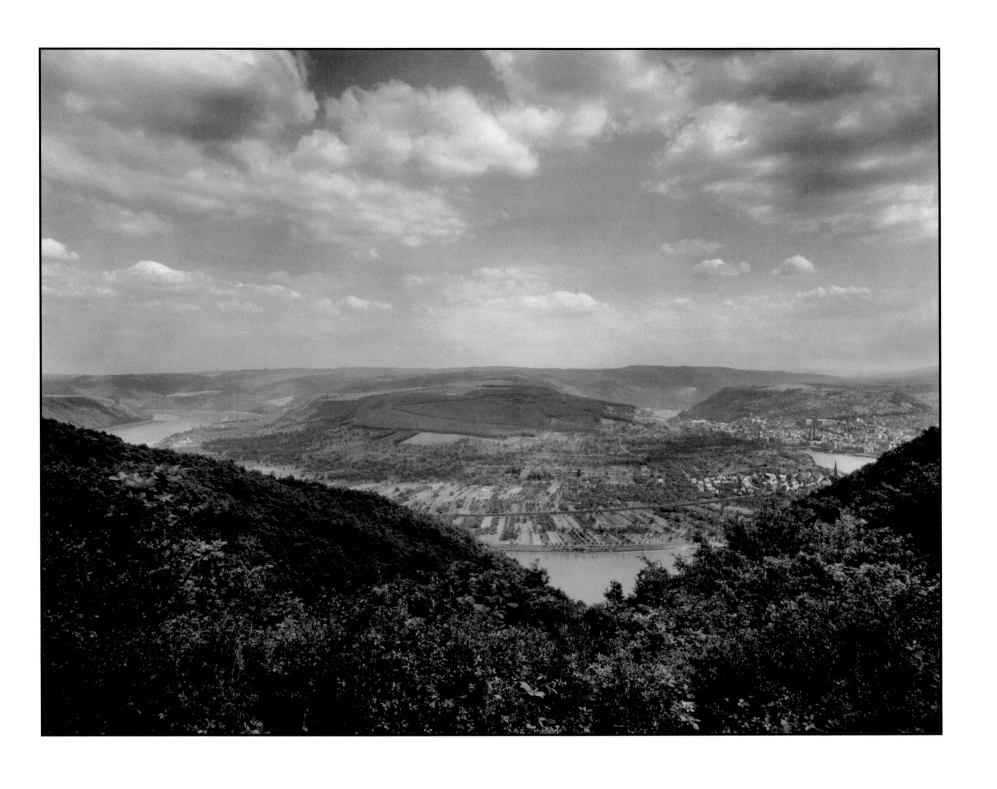

12. *The Four Lake View at Boppard*, 1938

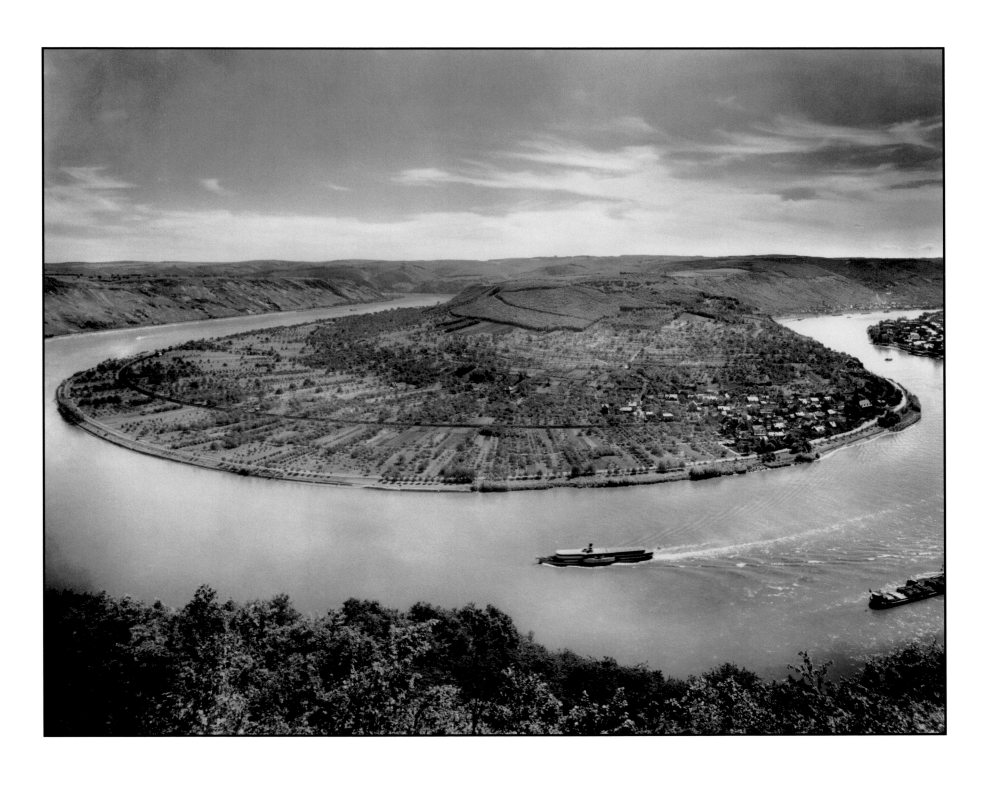

13. *Curve of the Rhine at Boppard*, 1938

14. *The Rhine at Honnef*, 1930s

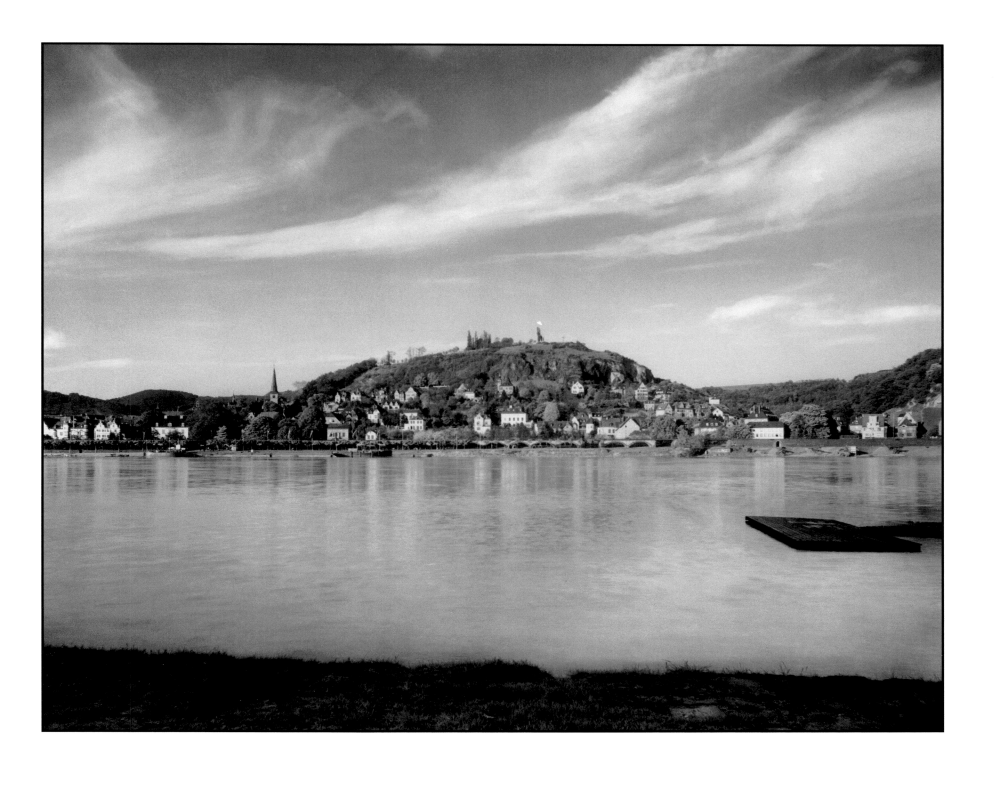

15. *Linz as Seen from Brück*, 1930s

16. *The Rhine at the Erpeler Ley,* 1930s

17. *View of Mondorf and the Seven Hills from Widdig,* 1930s

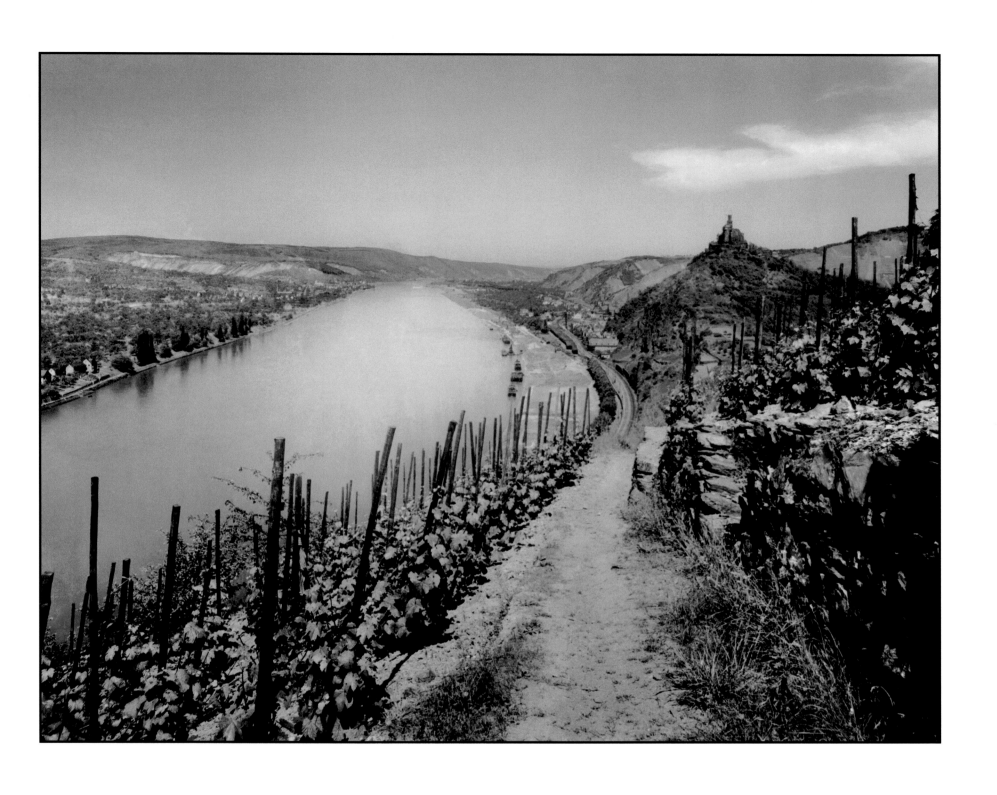

18. *The Marksburg at Braubach*, before 1933

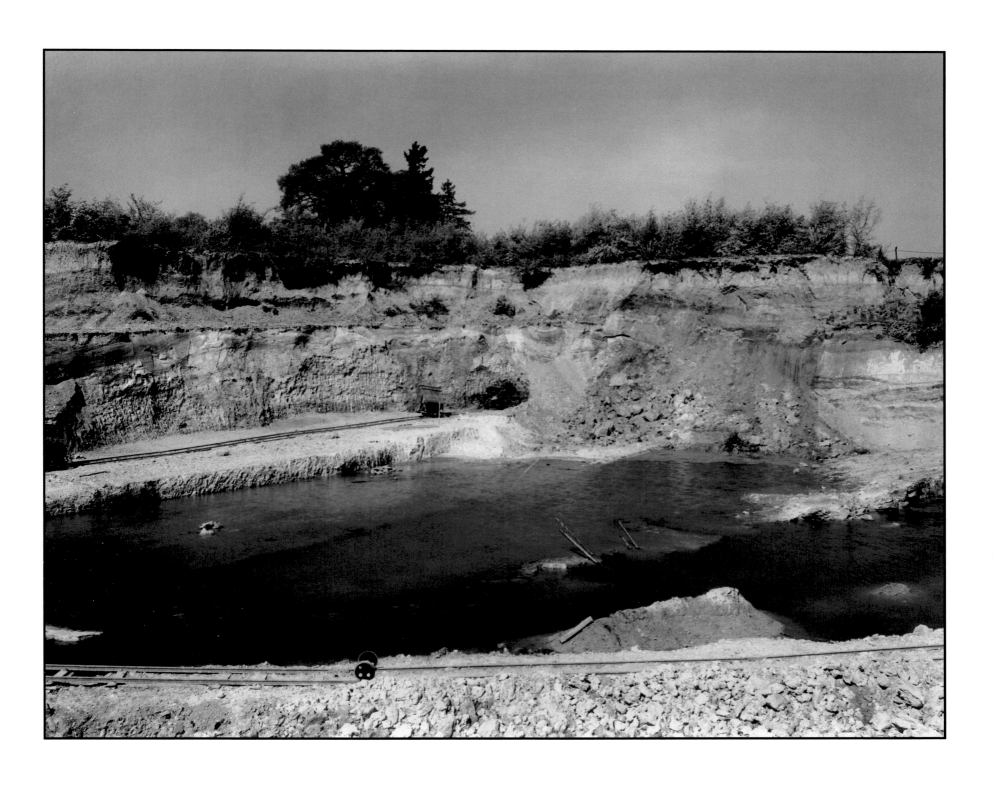

19. *Clay Pit on the Mönchsberg at Godesberg*, 1938

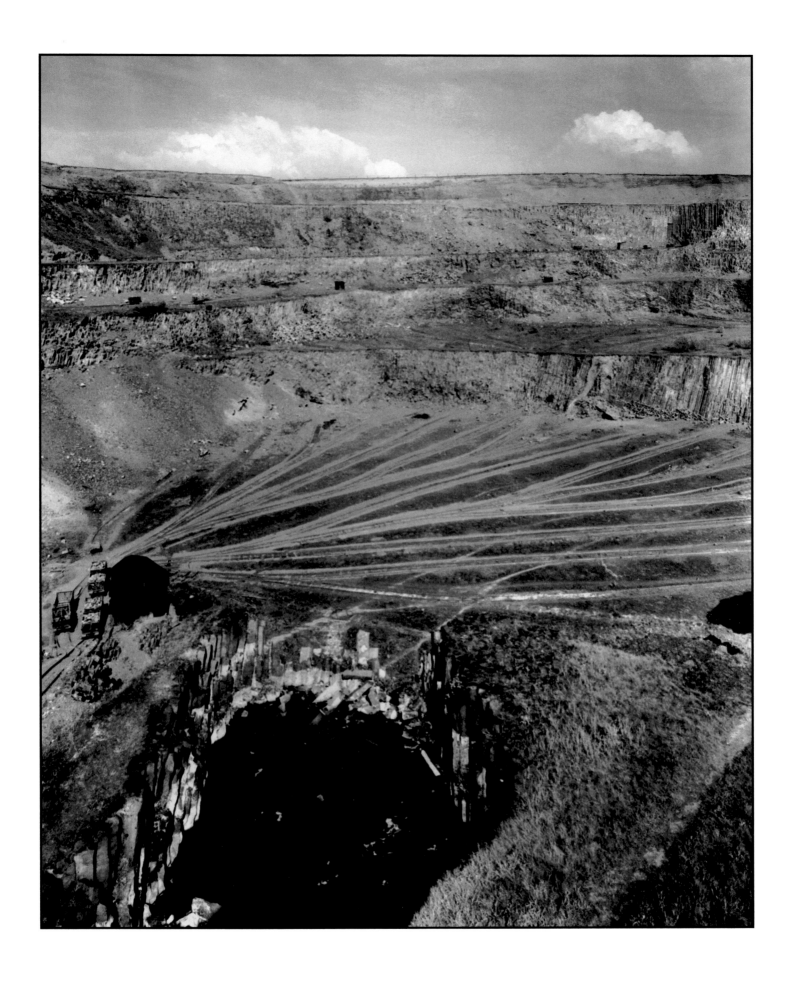

20. *Basalt Quarry near Dattenberg*, 1935

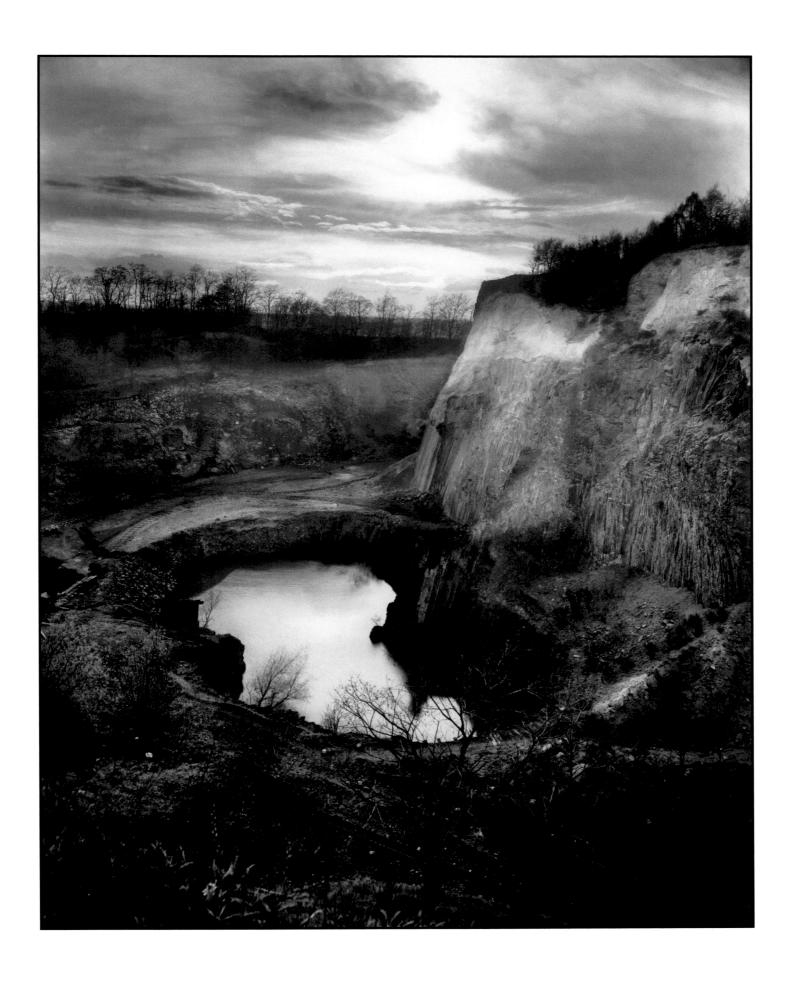

21. *Basalt Quarry in the Seven Hills*, circa 1938

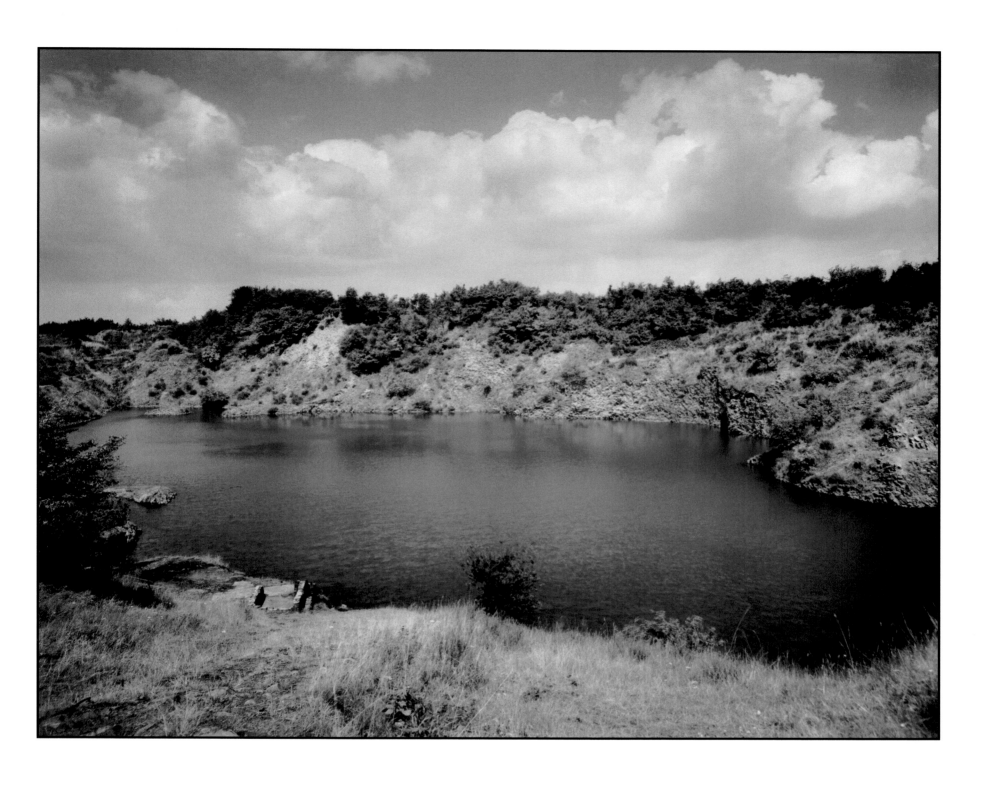

22. *Himbergsee in the Seven Hills,* before 1934

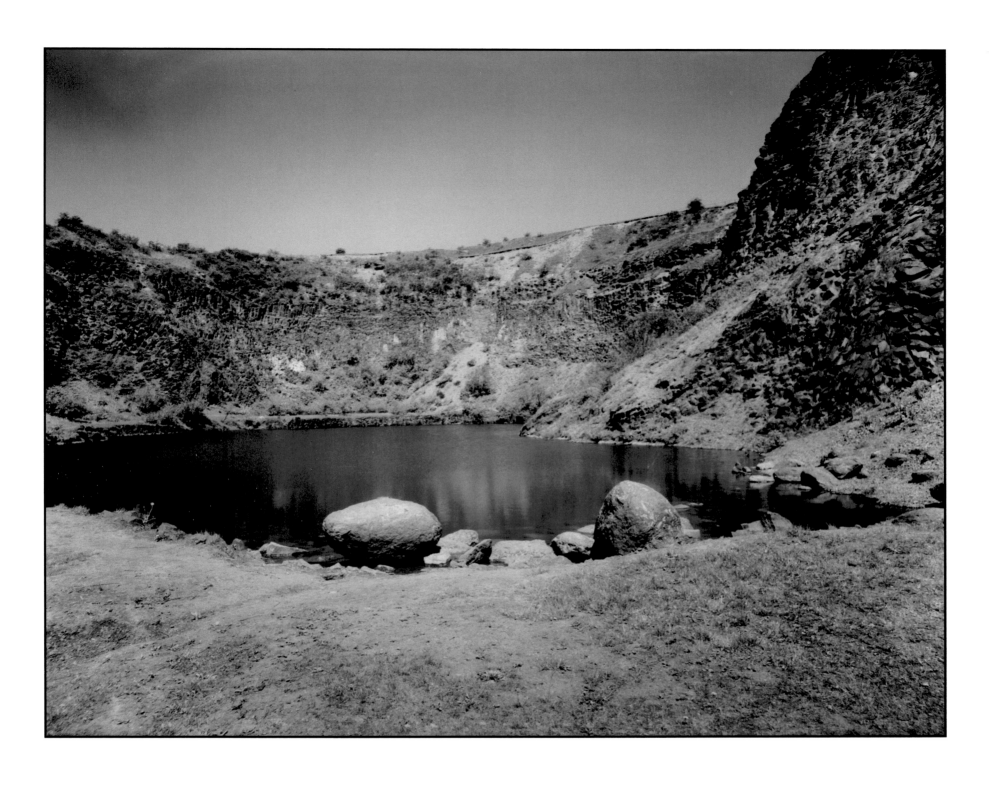

23. *Schwarzer See near Leubsdorf*, 1930s

24. *Pieces of Basalt at Schwarzer See*, 1930s

25. *Basalt Layers at Schwarzer See*, 1930s

26. *Basalt Quarry in the Seven Hills*, 1930s

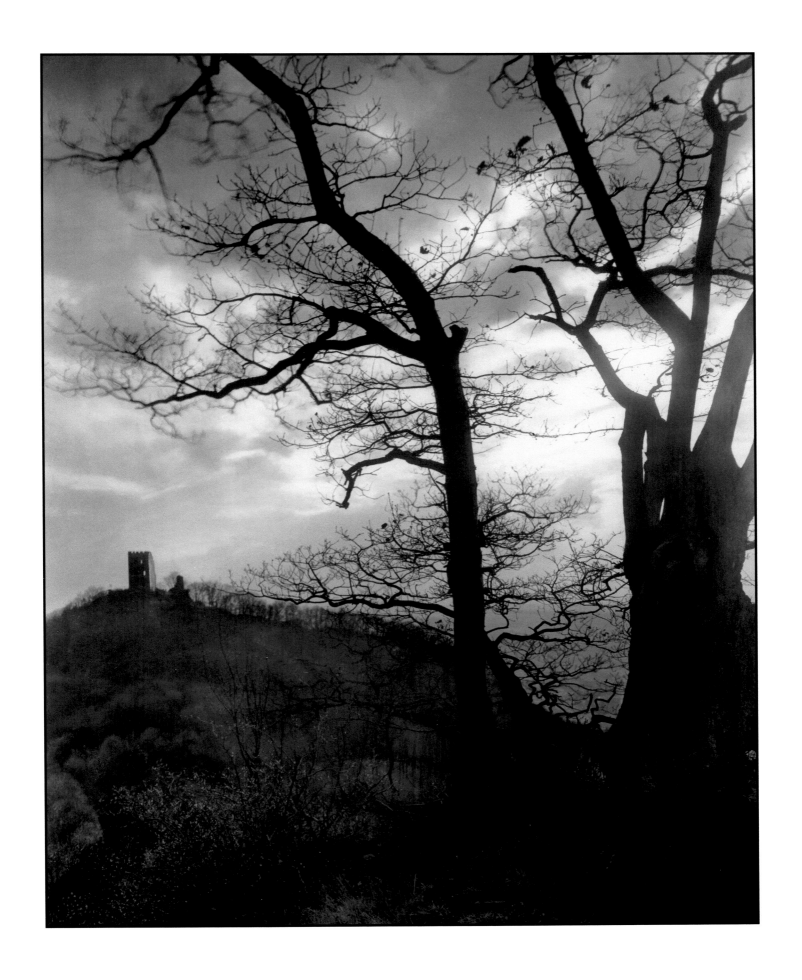

27. *Drachenfels in Autumn*, 1930s

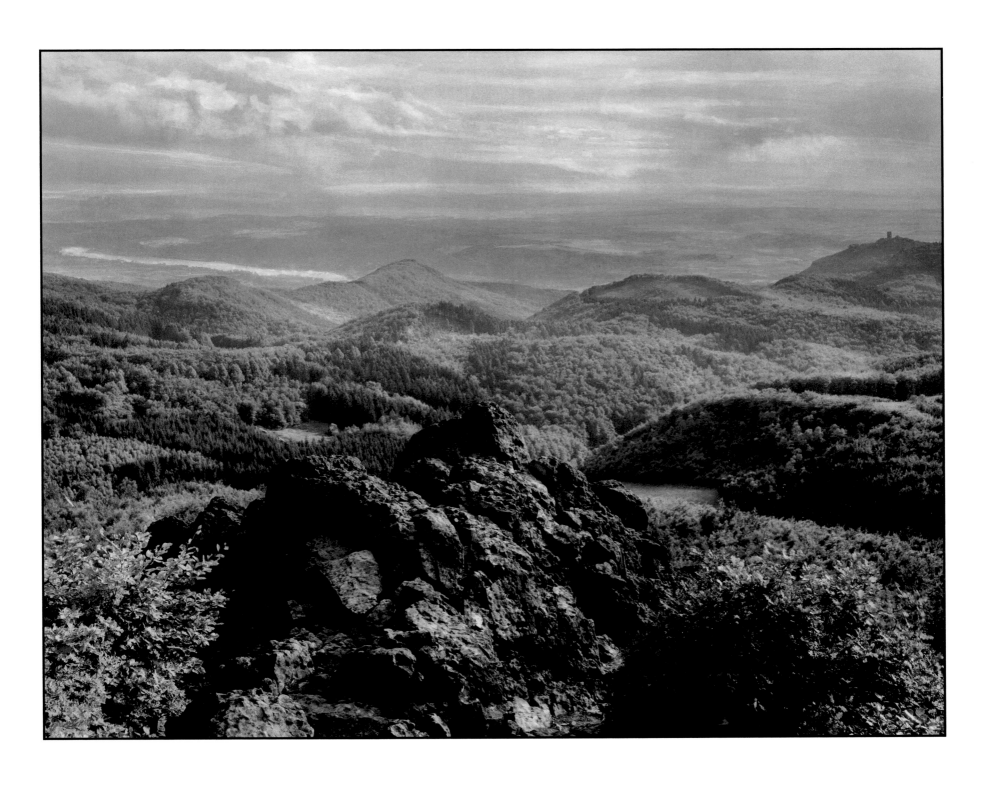

28. *View of the Rhine Valley from the Ölberg*, 1939

29. *The Rhine at Dormagen*, 1935

30. *Bingen in the Evening,* before 1926

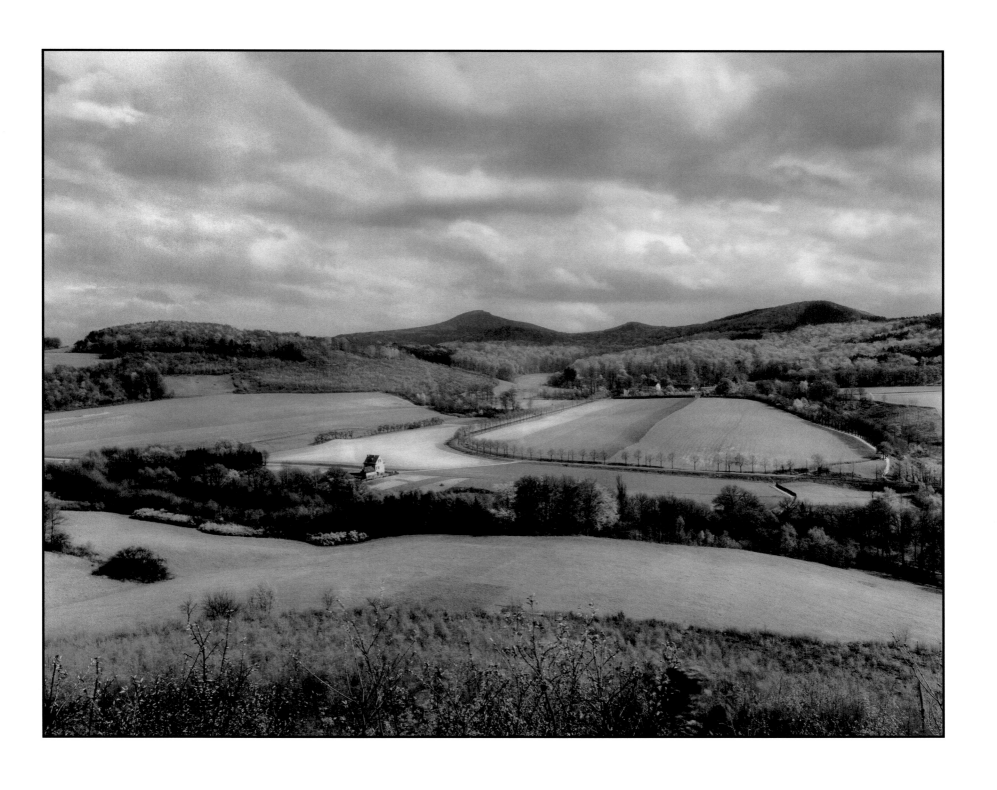

31. *Heisterbach with the Ölberg in the Background,* before 1934

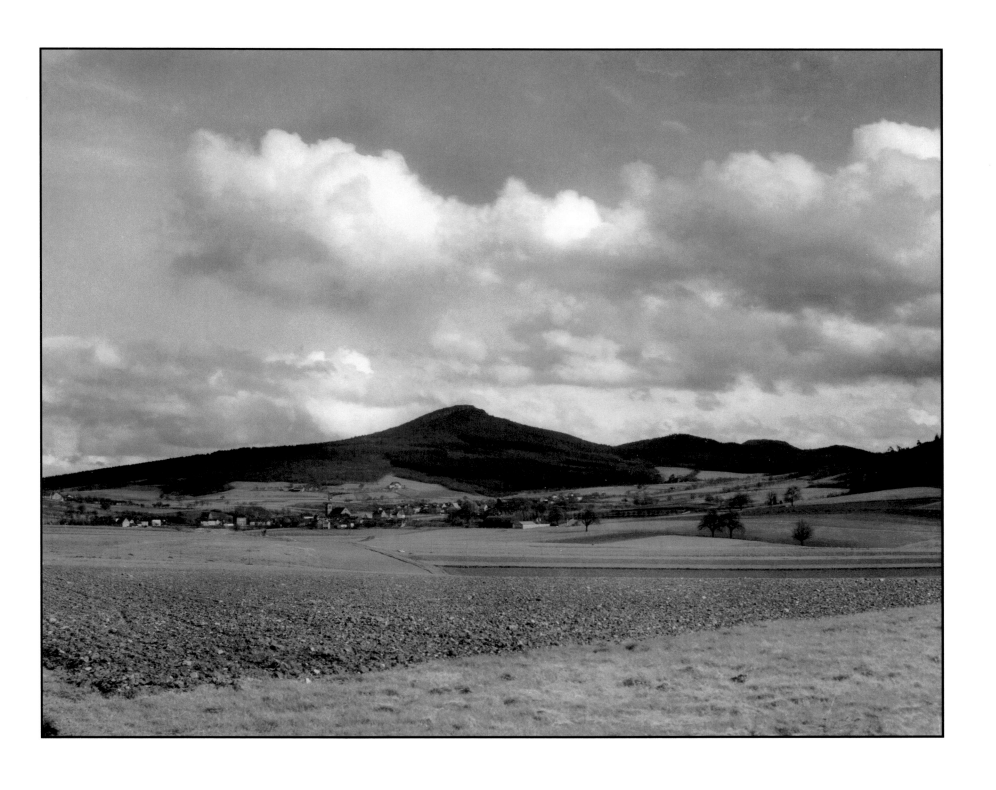

32. *Ölberg as Seen from Hasselbach*, 1930s

33. *The Seven Hills as Seen from the Westerwald*, after 1926

34. *The Seven Hills as Seen from Eichelhardt,* 1930s

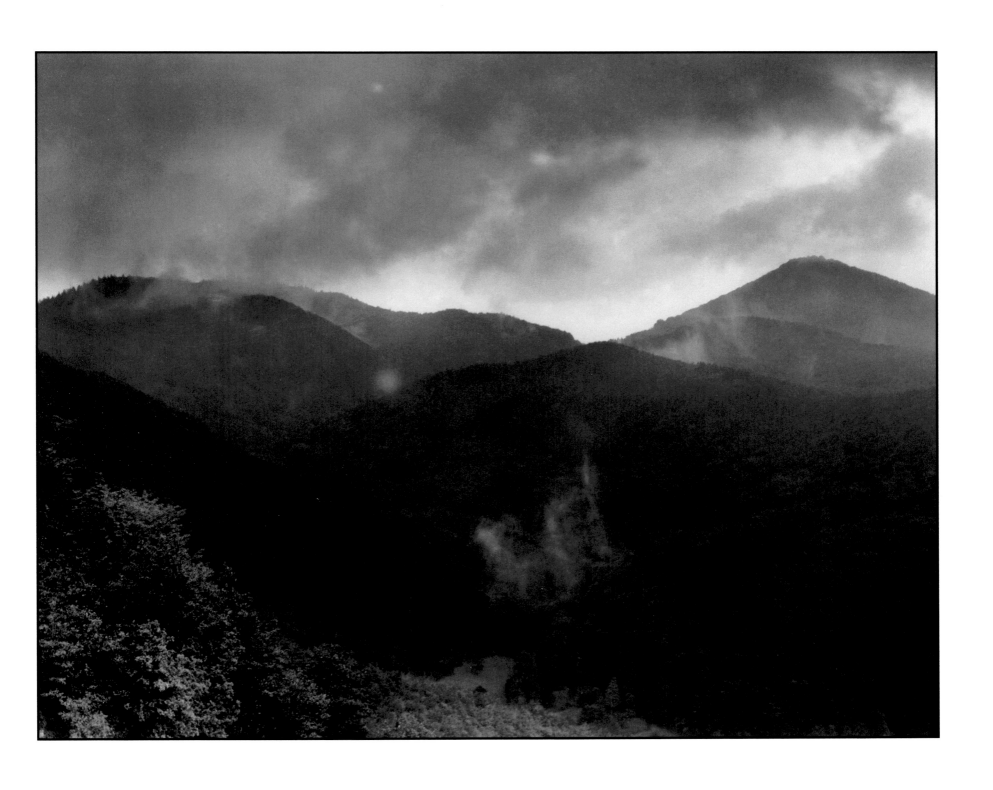

35. *The Löwenburg Shrouded in Fog,* 1946

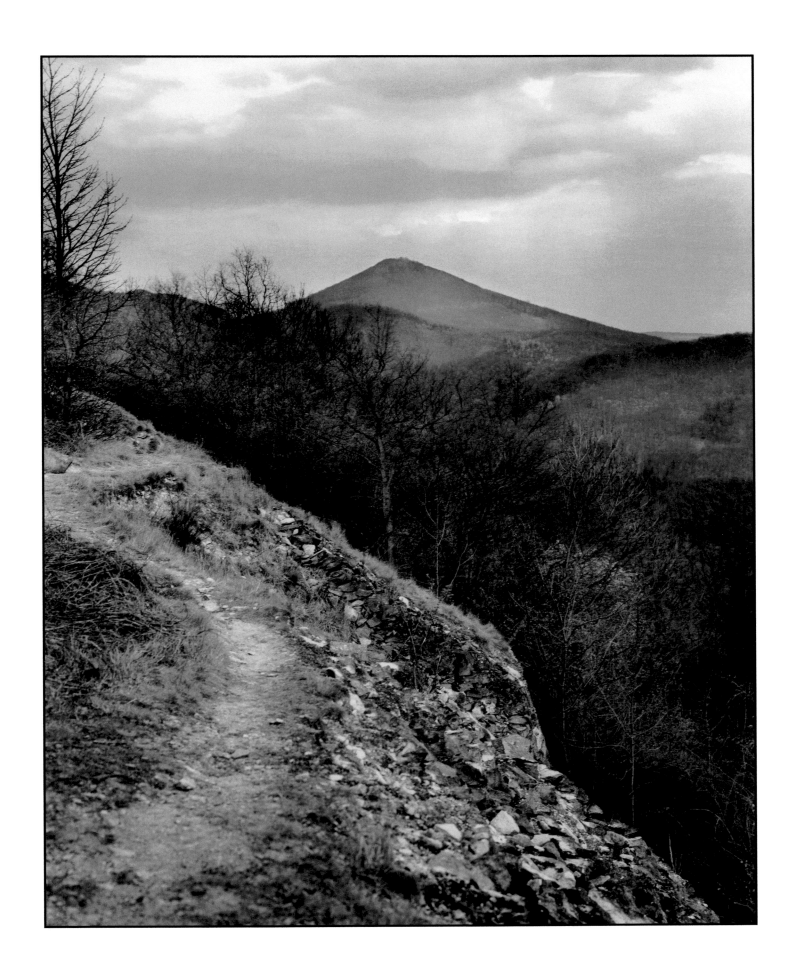

36. *View of the Löwenburg,* before 1934

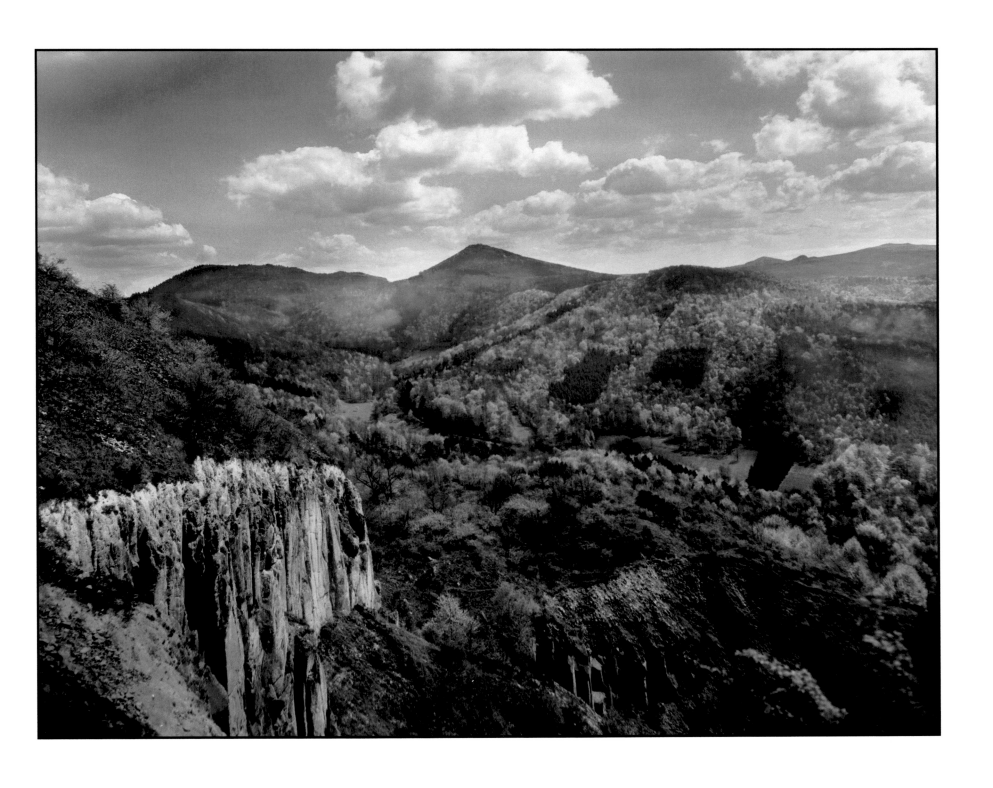

37. *View from the Wolkenburg (Spring)*, 1937

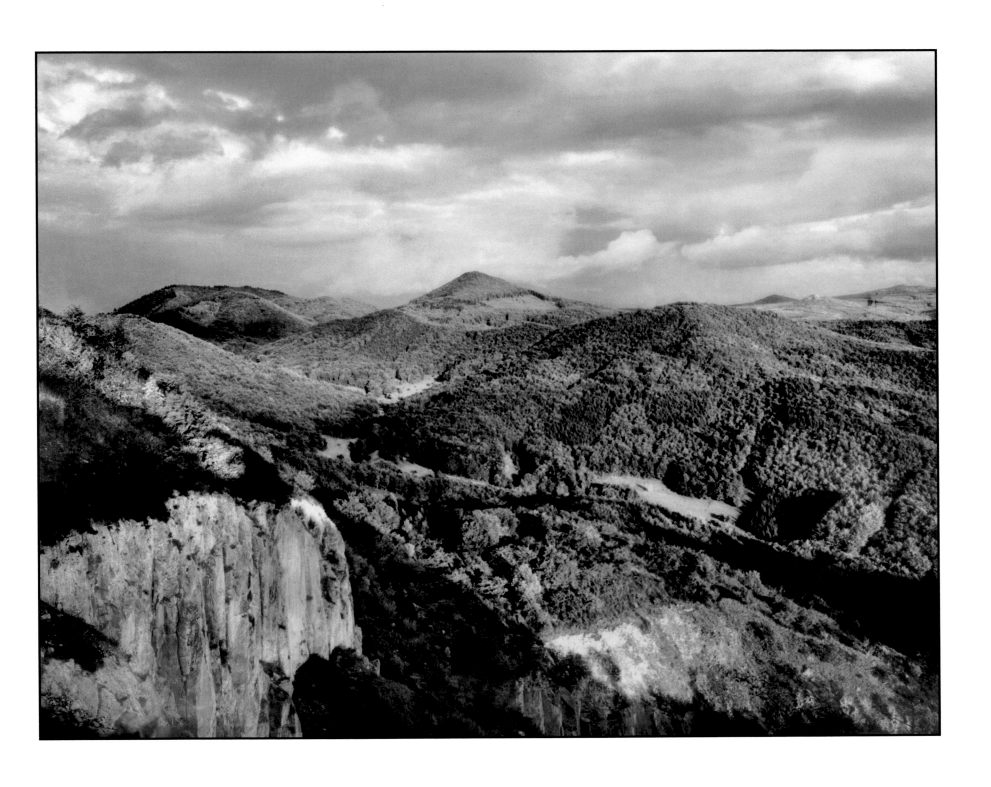

38. *View from the Wolkenburg (Summer)*, 1930

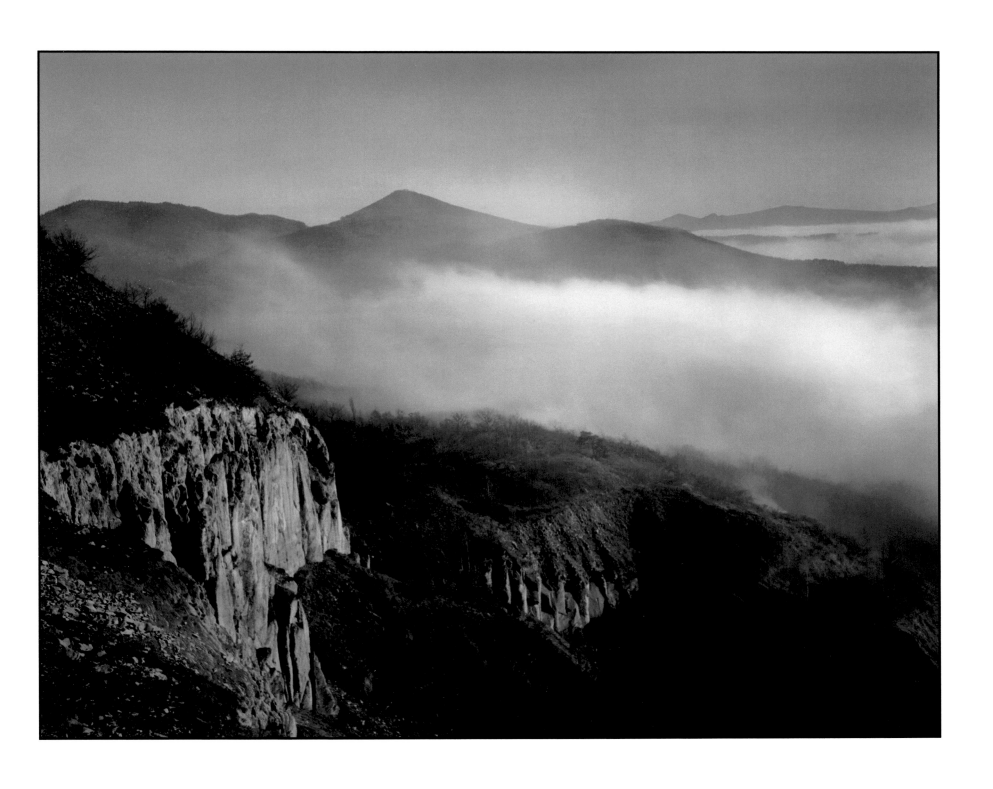

39. *View from the Wolkenburg (Autumn)*, 1936

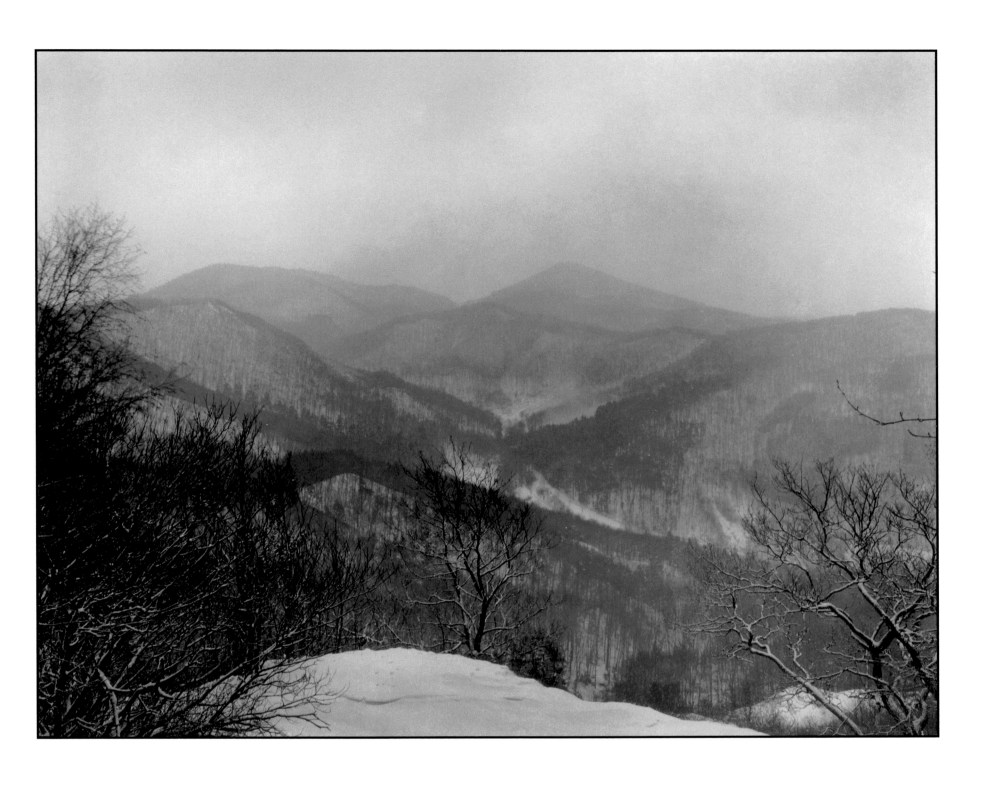

40. *View from the Wolkenburg (Winter)*, 1946

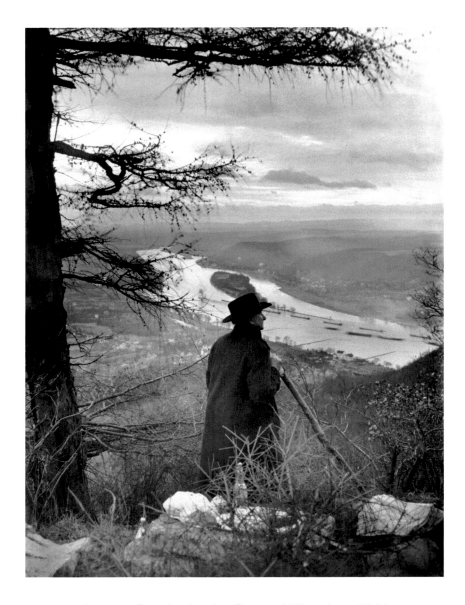

August Sander in the Seven Hills, circa 1941